RV CAPITAL
of the World

RV CAPITAL
of the World

A FUN-FILLED INDIANA HISTORY

AL HESSELBART

THE
History
PRESS

Published by The History Press
Charleston, SC
www.historypress.net

Cover photo *courtesy of Jayco*.

First published 2017

ISBN 9781540216588

Library of Congress Control Number: 2017931805

Notice: The information in this book is true and complete to the best of our knowledge. It is offered without guarantee on the part of the author or The History Press. The author and The History Press disclaim all liability in connection with the use of this book.

It is with much gratitude that I dedicate this story to the many RV industry giants who have encouraged, supported, mentored and educated me to involve myself in the study of RV history over the past twenty-five years, especially Harold Platt, who started with his company in 1935 and was still active sixty years later and loved to sit and reminisce; Herb Reeves, who started in the mid-1940s and had five separate ten-year careers, and his widow, Edna, who continued to support me as a volunteer at the RV/MH Hall of Fame into her nineties; and retired Michigan State University professor Carl Edwards, who, in the 1950s and '60s, headed the university's program offering degrees from bachelor's through PhD in RV and mobile home company management. They and many others have provided the knowledge that makes this book possible.

Contents

Foreword

I have known Al Hesselbart for many years through my activities as chairman of the Recreation Vehicle Industry Association's Public Relations Committee, a founding member of the industry's multimillion-dollar Go RVing marketing coalition, a longtime member of the RV/MH Hall of Fame and Museum Executive Committee and part of the RV industry for over forty-five years. In my mind, Al is *the* historian of the RV industry.

I had the opportunity to live many of the more recent events that are noted in this book and read with much interest the tremendous detail that Al includes.

- If I ever knew it, I had forgotten how Dometic gas-absorption refrigerators initially made their way to Indiana from Motala, Sweden, via a Russian immigrant, Leon Shahnasarian. How interesting that fifty years after that, Dometic would uproot its Sweden RV refrigerator factory and relocate it in Elkhart, Indiana.
- What is it about chicken coops, blacksmith shops and gas stations that make for good RV company incubators?
- What a great gathering of innovators and examples of risk-taking noting not only the tremendous successes but also the disappointing failures. Many are included here.
- Roots. Al got it right when he wrote about "RV University." So many of the industry notables have roots in many other RV companies,

having learned much before launching their own operations with their own approaches applied. Very interesting.

- Who knew that the Indiana RV industry was connected to the Manhattan Project? Apparently, Al did.
- What great reading about the evolution of Thor Industries and Forest River—the two giants of the industry—and how they came to be where they are at this point.

Before Al retired, he was working full time at the RV/MH Hall of Fame and Museum. He was my go-to guy when I brought Indiana governor Mitch Daniels around for a tour of the RV museum. Same thing with other legislators and celebrities and the producers of *Jeopardy!* Al was the guy who could be counted on to tell an inside RV story, provide an interesting factoid about the origins of motor camping or relate the history of the Mae West traveler.

This book clearly stands as a testimony that Al was and is *the* RV industry's historian. With his passion and excitement for the industry's growth and evolution, we see that he also continues as a cheerleader for all things RV.

—B.J. Thompson

An RV industry activist and promoter for over forty-five years, B.J. Thompson has been a member of the Recreation Vehicle Industry Association (RVIA) since 1980, chairman of RVIA Public Relations Committee for over thirty years and a founding member of Go RVing Coalition. He was elected to RVIA's board of directors for six three-year terms. He earned RVIA's Distinguished Service to the RV industry, the RVIA National Service Award and the RVIA Spirit Award. He was inducted into the RV/MH Hall of Fame in 2005 and received the RV/MH Spirit Award in 2010.

Introduction

The state of Indiana holds a very important position in the rich history of the recreational vehicle industry and its related travel and camping lifestyle. For over seventy years, since the World War II years of the 1940s, the northern city of Elkhart and the surrounding area near South Bend have been identified as the RV Capital of the World for the high number of trailers and motor homes made there and the great number of manufacturers and component suppliers based there. In the immediate post–World War II days, there were several areas of concentration of trailer builders spread throughout the country. Southern California, especially the area around Los Angeles, hosted many of the dynamic early manufacturers, as did parts of New York, Georgia and Alabama. As the industry evolved, however, none could compare to the growth in northern

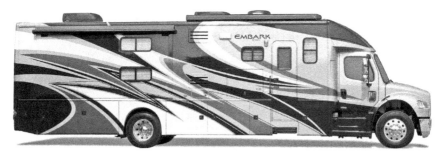

The 2014 Jayco Embark. The Embark is one of today's giant "mobile mansions" based on stretched highway tractor chassis. *Courtesy of Jayco.*

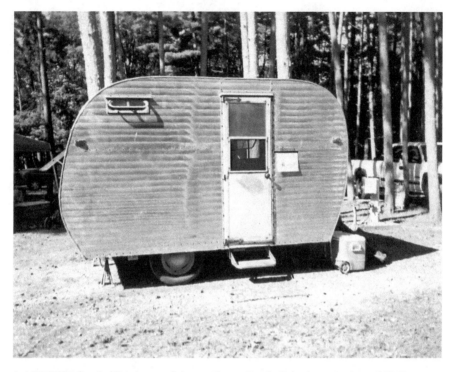

A 1955 FAN Coach. This is one of the smaller trailers built in the early days of FAN. *Courtesy of Al Hesselbart.*

Indiana. Surely today, over three-fourths of the recreational vehicles built in America are produced in the Greater Elkhart–South Bend area of north-central Indiana and southwest Michigan, continuing that status to a greater degree than ever before.

Indiana's place in the early history of the RV, however, was established in the years before World War I, when a few companies around Indianapolis began building and selling camping trailers. These dreamers were the visionaries who wanted to put beds inside of or behind the first rudimentary automobiles to enjoy a weekend retreat and found that their neighbors wanted the same opportunity. While these original camper manufacturers enjoyed only regional distribution, they surely set the stage for Indiana's place in the RV world.

CHAPTER 1

The RV Industry Begins

A s soon as the earliest autos began to appear on American roads, enterprising woodsmen, hunters, campers and other outdoors-oriented families began to create their own camping vehicles to tow behind the new motorized vehicles. At first, these campers were pretty much homemade lightweight rustic mobile tents created one at a time. Around 1910, a few enterprising entrepreneurs began to produce multiple rigs to sell to their friends and neighbors. The popularity of camping as an American pastime was so great that soon commercial production companies began to appear. It must be remembered that these very first builders were true visionaries who had to create their first campers from their dreams. They did not have predecessors to improve upon but had to design and build saleable campers from visions in their minds. Surely, they had the examples of the tents of our pioneers and the military, but the concept of towing a workable shelter behind rudimentary vehicles was beyond most citizens' wildest imaginations. In fact, for many of the early years, those campers who chose to use trailers for recreation travel were looked upon as ne'er-do-wells and were commonly referred to as gypsies, tramps, thieves or tin can tourists because there was no way to establish where they were living.

One of the first commercial camper builders in the country was Edward Habig of Indianapolis, who began building a folding tent camper as early as 1915. During these very early years of horseless carriages, tin lizzies and other motorized conveyances, those citizens who felt America's great wanderlust quickly joined the automotive society. Since the early vehicles were not

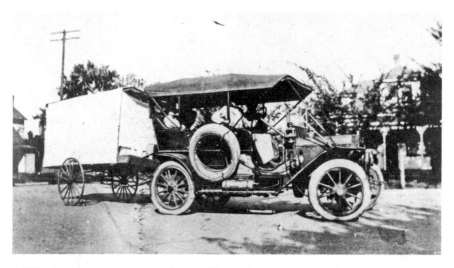

A 1910 vintage camper, maker unknown. The earliest campers were simply a platform covered with a light frame over which a canvas cover was draped that stayed light enough to be towed by the early autos. *Courtesy of the RV/MH Hall of Fame.*

capable of towing much weight, the earliest campers were, for the most part, lightweight tent trailers. A few enterprising builders also created motorized "housecars" on some of the early heavier truck-like vehicles. While most of the early tent campers were basically a standard tent that was erected on a wheeled platform, Habig's Cozy Camper contribution is recognized as the first folding tent camper to offer a hard, flat roof like today's campers, as opposed to the peaked canvas tent-like roof shape of the other camping vehicles of the day. The rigid flat roof also allowed Habig to be the first to provide an electric light on the ceiling instead of the open-flame candles and lanterns used in the alternative designs. The Cozy Camper sold for $165 in 1916. While the price seems exceedingly low today, it is important to remember that at that time, many workingmen were compensated at five cents per hour or forty or fifty cents per day.

Another early provider of camping vehicles was the Hercules Buggy Works of Evansville, a large, well-established builder of horse-drawn and motorized vehicles and vehicle accessories, especially canvas convertible tops for early runabouts, which were often sold as open vehicles without tops. Runabouts were the early two-seater autos that were much like motorized versions of the horse-drawn buckboards. Hercules marketed some of its accessories and add-on bodies through the Sears and Roebuck catalogues. In 1916, Hercules introduced a folding tent trailer to its extensive vehicle lineup. It also built an

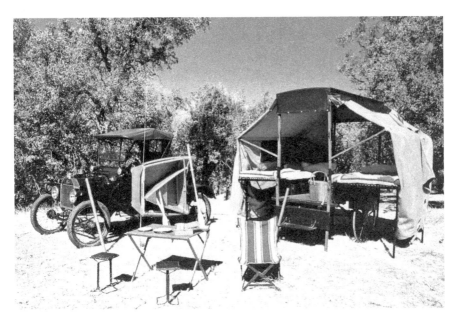

A 1915 Habig Cozy Camper trailer. This was the first production camper in Indiana.
Courtesy of Al Hesselbart.

empty body shell that could be, and sometimes was, easily used to create a housecar, as the early motorized campers were identified. Most of these early builders distributed their products in a fairly small two-hundred- or three-hundred-mile radius around their plants, as widespread transportation of large products was very difficult and usually done by railroad, not highway.

The Continental Auto Parts Company of Knightstown introduced a full line of four camper models in 1917. The Scout was a simple tent and suspended mattress configuration that could be mounted on a car's running board to provide some shelter for sleeping. The 49er was a very basic trailer where a small tent rose up above the trailer box and held a standard-sized mattress for a more comfortable night's sleep. The Wigwam was a more recognizable modern conventional camping trailer design in which two full-sized beds folded out on either side of the trailer box, and the Pathfinder was basically the same design but came equipped with a rudimentary ice chest cooler and a camp stove, as well as some storage compartments.

In the 1920s, other Indiana trailer builders came into the national picture. In 1925, E.R. Gilkison and Sons in Terre Haute began making a camper that became nationally popular. The Gilkie brand trailers received U.S. patent number 1,696,113 in 1926 and continued to build both folding tent trailers

15

A patent issued to E.R. Gilkison for the original popular Gilkie folding tent trailer. *Courtesy of the U.S. Patent Office.*

A 1932 Gilkie Camp King camper. This is an example of the pioneering campers made in Terre Haute by E.R. Gilkison. *Courtesy of the RV/MH Hall of Fame.*

and hard-bodied campers into the early 1950s. In the early 1930s, Gilkie built two models. The De Luxe had an insulated hard roof like Habig's earlier Cozy Camper and was an early predecessor of the later rigid-sided campers, while the Camp King folded up to a peaked roof. Both offered two fifty-four-inch comfortable beds, and the Camp King included a built-in insulated ice chest and an enclosed pantry space. By the mid-1930s, the Gilkie lineup included the two tent trailers, a conventional travel trailer and one of the very first commercially built horse trailers.

CHAPTER 2

The Elkhart Story Begins

While still growing elsewhere around the state, the trailer industry began rapidly to concentrate in the South Bend–Elkhart area in the early 1930s. The north-central Indiana area had long been identified with transportation and vehicles. The Studebaker Company, builder of the early Conestoga wagons, Studebaker autos and World War I–vintage military vehicles, was based in South Bend, and several well-known post–Civil War buggy and carriage brands—including Elkhart Buggy and Harness, Brewster Buggy and the Noyes Carriage Works—as well as the 1920s Elcar, Crow and Pratt automobiles, were all made in Elkhart. The town was also a major railroad hub where the New York Central and Pennsylvania Railroad main lines crossed on their way from the east toward Chicago. In addition, two major east–west highway thoroughfares, U.S. 20 and U.S. 33, as well as the famed Lincoln Highway, came through Elkhart and South Bend. In addition, Elkhart sits at the confluence of three rivers, the St. Joseph, the Elkhart and Christiana Creek, and South Bend gets its name from its position on the southernmost bend of the St. Joseph River as it flows toward Lake Michigan, so there was a nearly unlimited supply of available water for any manufacturing needs.

In this historic transportation area, Milo Miller, a Mishawaka-based house painter forced out of work by the effects of the Great Depression, developed a dressing for the canvas auto top inserts of the day and proceeded to market and apply Auto Top Rejuvenator, a concoction he

created based primarily on a mixture of tar and gasoline, to auto owners throughout the Midwest. Miller would set up shop outside the gates of large factories and sell his top-renewal service to workers as they arrived for work to be completed when their workday was finished. As his travels went farther and farther afield, he built a rustic camp trailer from plywood and junkyard auto parts so that his family could accompany him on his business trips. His first trip with the family camper took him to the huge Dow Chemical facility at Midland, Michigan. There being no organized local campgrounds in the early 1930s, the Miller family set up camp in a country schoolyard where a water well and an outhouse toilet were available close to his target factory.

His ingenuity in homemade living arrangements drew so much attention from passersby that he shortly began to get offers to buy the camper. Soon, he received an offer that he did not feel he could

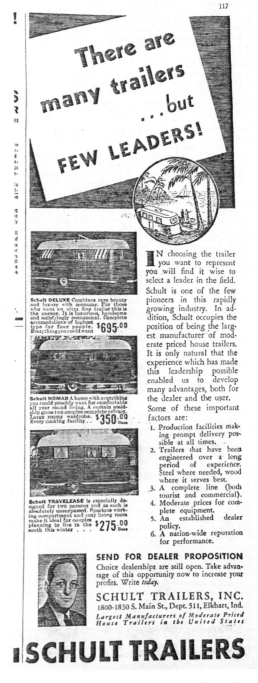

A 1937 Schult ad showing the price range for early trailers. *Courtesy of the RV/MH Hall of Fame.*

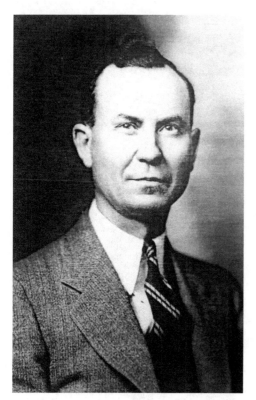

Left: Milo Miller was the pioneer who introduced RV production to the Elkhart–South Bend area. *Courtesy of the RV/MH Hall of Fame.*

Below: A 1933 Miller trailer. This is an example of the original trailers built with junkyard auto parts. *Courtesy of Al Hesselbart.*

refuse, and he sold his trailer, leaving his family temporarily homeless more than a full day's journey from their home base. He simply found a local junkyard, bought the needed parts and quickly assembled a second trailer on the spot. When this second trailer also sold before he left Midland, Miller returned to Mishawaka and, in 1932, began building trailers to sell in a rented shed at the Lowe Lumber Yard on the city's south side. He established his company with an initial investment of $90 for rent and an agreement from the lumberyard to provide materials on consignment one trailer at a time. He continued to source his axles and frames from local junkyards. After two years of success with this formula, he became more conventional in his construction and design and relocated his Sportsman Trailer Company from the lumberyard shed to a vacant former blacksmith shop in nearby Elkhart. Milo's trailers popularly sold for $168 at this Great Depression time.

At the same time that Miller was creating his trailer company, Wilbur Schult, the son of a well-known Elkhart men's clothier, visited the large 1933 Chicago World Exposition, where he became enthralled with the new camping trailers at the infant industry's large display at the fair. Returning to Elkhart, Schult attempted to get his father to finance his acquisition of a trailer or two to begin a retail sales business in Elkhart. When his father refused to invest in Wilbur's "folly," he approached his mother, who agreed to loan him a few hundred dollars of her "pin money."

With that meager stake, Schult traveled to Detroit to purchase for resale one of the Covered Wagon–brand trailers that he had most admired at the Chicago fair. The Covered Wagon Trailer Company was at this time the largest trailer manufacturer in the country. He was successful in getting one trailer, with which he returned to Elkhart and set up his trailer sales lot, with an inventory of one, at the curb in front of his father's store. When that first trailer sold rather quickly, he prepared to return to Detroit for another but then learned that the customer's check had bounced. Not knowing where his customer had gone, he was out both his trailer and his money. Being a very brash and optimistic young man, he went back to the company empty-handed and was surprisingly able to secure a second trailer on consignment. When that trailer also sold quickly and the funds were good, the Schult Trailer Mart was started, with display space on the South Main Street curb in front of the spot where the Elkhart Post Office stands today and his office inside his father's men's store. When his business grew quickly, in 1934, Schult relocated his Trailer Mart off the street

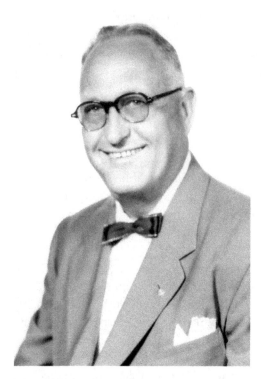

Wilbur Schult was the marketing genius who grew his Elkhart company to become the largest trailer builder in the world by 1939. *Courtesy of the RV/MH Hall of Fame.*

curbside position to space in a lot on East Jackson Street still in downtown Elkhart. From that location, he also became a national retail and wholesale distributor for Milo Miller's locally made Sportsman Trailers, in addition to the Covered Wagon products. He promoted his dealership widely by running advertising in *Billboard* and *Variety* magazines in hope of attracting customers from the carnival and show business people, many of whom lived and traveled in the early trailers.

In 1935, Oliver Platt—a local railroad manager who also operated a fox farm supplying furs for the garment industry—and his sons Harold and Eldon purchased the foundering Doloretta trailer works and began to make trailers in Elkhart. Doloretta had primarily made folding card tables, with some trailers as a side line. When they quickly turned the business around, the Platts renamed their product the Platt Trail-a-Home. Harold became a nationally known activist promoting the fledgling trailer industry from coast to coast.

These three companies, formed in the depths of our nation's Great Depression, became the core for the Elkhart–South Bend area's dynamic growth into becoming known as the Trailer Capital of the World. The three dedicated visionary entrepreneurs each worked tirelessly not as partners but as friendly competitors to grow their own companies but additionally with local and national associations of both manufacturers and dealers to establish and promote what they each recognized as an infant industry serving an enormous demand among the American public. Each of the three worked not only in support of all trailer manufacturers

but also in helping to establish a network of dealers who would deliver the trailers to the customers. They were far from alone, however.

The enormous growth in the number of trailer manufacturers was far from the whole story. In order to enable a dynamic increase in builders, it was necessary to have a similar increase in companies to supply all of the various components needed to assemble the trailers. As the number of trailer builders around Elkhart and South Bend began

PROOF *from*

Field & Stream

578 Madison Avenue, New York City

FIELD & STREAM—MARCH

Field & Stream—March, 1936

SCHULT'S
House Trailers
$168 $198 $275 $315
Others $398 to $1000
No Sales Tax
SCHULT'S TRAILER MART & FACTORY
605-607 Main St. Elkhart, Indiana

Top: A March 1936 ad proof. This would be the first ad showing Schult as a trailer builder, as he had taken over Miller's factory. *Courtesy of the RV/MH Hall of Fame.*

Right: Harold Platt was one of the true pioneers of the RV industry, both in Elkhart and nationally. He was significantly involved in guiding the industry's support of our effort in World War II. *Courtesy of the RV/MH Hall of Fame.*

to grow in the years preceding World War II, a parallel growth started in the development or warehousing of all the various supplies they required. The area began to see a rise in the availability of lumber services, floor coverings, appliances, seating, cabinetry and all the other needed parts. There was also the need for retail services to bring the finished products to the general public and for campground operators to give the new owners a destination where they could use and enjoy their campers.

In 1936, Steve Stanley left his employment with the Platts and went to Mishawaka, where he started the Stage Coach Trailer Company. The famous Charles Lindbergh trailer in Detroit's Henry Ford Museum is a product of Stanley's short-lived Stage Coach operation. When, in its first year, Stanley's venture began to fail, Norman Wolfe, who owned the Silver Dome Trailer Company in Detroit, joined with Ralph Kennedy from Cozy Coach in Kalamazoo to purchase the company and relocate it to nearby Cassopolis, Michigan. They renamed it American Coach, and it grew to become one of the national giants of the late '30s, '40s and '50s.

Also in 1936, Ernie Harris approached Oliver Platt in hopes of investing in the rapidly growing Platt Trail-a-Home, but his effort was rejected. Harris then started the Harris Caravan Coach Company in a building on McDonald Street in Elkhart. In 1937, Harris relocated his operation to a plant in Plymouth, but it did not succeed and failed less than one year later. Platt then acquired the McDonald Street building that Harris had vacated and continued trailer production from that facility until 1960.

In January 1936, Milo Miller, having outgrown his small blacksmith shop location, moved into rented space in the giant abandoned Noyes Carriage Works factory on South Main Street in Elkhart. Almost immediately, in March, he sold his operation to his dealer, Wilbur Schult, who renamed it Schult Trailer Coach. Miller then acquired space in the Beardsley Street building on Elkhart's north side where the 1920s Elcar automobile had been built and started the Elcar Trailer Company, taking advantage of the name still painted on the building to become his company identity. That venture grew so rapidly that he sold it for a profit only eight months later in December 1936 and relocated his efforts to a building in Elwood, Indiana, where he formed the National Trailer Company. He shortly was required to move into a larger factory in Huntington. The National Trailer Company rapidly became successful and, employing over five hundred workers, became one of the largest suppliers of trailers to the government

DEALERS

Here Is What You Have Been
Waiting For

A Beautiful 20ft. Custom Coach

$745.00

1938 Models Now Ready

Complete with oven range and steel ice box.

Built by Pioneers in the Trailer Industry

TWO OTHER MODELS

16 Foot DeLuxe...................................$495.00
*18 foot DeLuxe...................................$695.00
*Complete with oven range and steel ice box.

Some dealer territory still available. ACT NOW. NATIONAL ADVERTISING CAMPAIGN NOW IN PROGRESS.

STAGE COACH TRAILER CO.

1703 Ironwood Drive South Bend, Ind.

"The Trailer That Square Dealing Built"

J. P. Williamson S. J. Stanley T. D. Williamson

A 1938 RV advertisement showing Depression-era pricing for RVs. *Courtesy of the RV/MH Hall of Fame.*

for temporary housing at military bases and defense plants during World War II. Plants and bases grew so quickly as the United States entered full speed into the war following the attack on Pearl Harbor that it was impossible to build homes fast enough to house all the workers and their families attracted to the burgeoning plants and bases. Trailers thus became the immediately available living quarters. Having started three successful trailer companies, Miller sold his interest in National at the end of the war and retired from the trailer business in which he had become a national icon in a career that lasted just over ten short years. Having taken the National Trailer Company public, Miller was recognized as the first trailer manufacturer to offer stock options as incentive rewards to his employees. Milo continued to serve the trailer industry for many years as a freelance consultant and advisor to many companies.

Early in 1936, the large Rex Top Company of Connersville, southeast of Indianapolis, a builder of convertible tops and various accessories

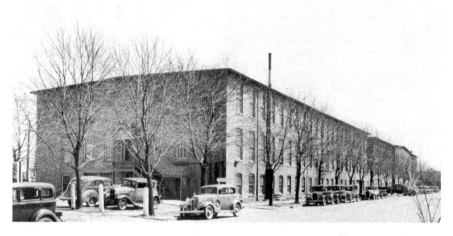

The Schult trailer factory #1. This is the old Noyes Carriage factory on Elkhart's south side from which Schult took over Milo Miller's company in 1936 and became the world's largest trailer builder. The building was demolished in 2015. *Courtesy of the RV/ MH Hall of Fame.*

for most of the early auto manufacturers, designed and introduced a small folding camping trailer light enough to be pulled behind the early autos. The Rex trailer opened out and provided shelter and sleeping arrangements for a family of four. It sold for $149. The camper trailer division of Rex was successfully sold off a few years later to an Indianapolis company. In the years around World War I, the Rex Company produced the Empire brand automobiles.

Late in 1936, a Mr. Rice approached Platt Trail-a-Home with a request that they design and build a special trailer in which he could sleep and from which he could make and sell the new waffle-style ice cream cones that he had invented and sold at fairs and carnivals as he worked the events throughout the midwestern states. With Rice, Harold Platt designed and built what was the first known concession trailer. Reportedly, Rice was so happy with his trailer that he became a salesman for Platt, promoting and selling the early concession vehicles to other concession operators at fairs and carnivals for a commission as he traveled. Platt failed to patent or copyright the concept and design, and so within very short order, many trailer companies were making the new food-vending trailers.

Harold Platt was always very active as a promoter of the new trailer industry in addition to leading his company in the manufacture of trailers. In 1936, he was instrumental in the formation of the Trailer Coach

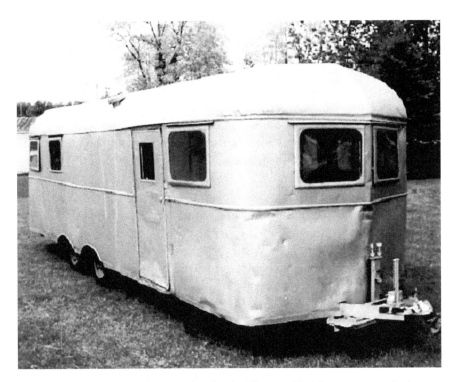

A 1939 Platt trailer. This is the type of trailer that Platt provided the government for base housing during the war. *Courtesy of Al Hesselbart.*

Manufacturers Association (TCMA), the first national organization of builders getting together to promote and guide their industry. In 1937, he was on the committee to develop the first large regional trailer show and sale. His 1937 deluxe model is recognized as the first trailer to include a full bathroom with a tub. He was also one of the first builders to install a kitchen range that included an oven in his trailers instead of the commonly used two- or three-burner countertop hot plate.

When World War II began, Harold was appointed by the national trailer manufacturers' association to represent the trailer industry on the War Production Board, which allocated supplies and orders to companies during the period of material rationing during the war. Following the war and through the 1950s, Platt primarily made the larger trailers that were commonly used as residential but could still legally be pulled behind a family car. He did, however, continue to build some very popular camper trailers. In the later '50s, under government contract, he built some very specialized highly insulated trailers that had skis instead of wheels and

were designed to be pulled across the arctic ice and situated as housing and offices for the personnel manning the Cold War DEW LINE early warning system across northern Canada and Greenland. In the early '60s, as mobile homes became larger and larger and would no longer fit on his assembly line, he closed his manufacturing operation and opened an RV dealership on Cassopolis Street in Elkhart. In that role, he eventually became the first franchised dealer for both the locally built Coachmen and Jayco brands that evolved into industry giants.

Very shortly after creating Schult Trailer Coach from Miller's Sportsman operation in March 1936, Wilbur Schult set off on a period of rapid growth pretty much unequaled by any company in any industry. After he severed his relationship as a dealer with the Covered Wagon Company, he charged full speed ahead with his aggressive national marketing campaign. Within a year, he had grown his production to occupy all three floors of the building in which Miller had used only one. He added another local factory in early 1937, bringing his manufacturing space to exceed 250,000 square feet. When he acquired a factory in Ottawa, Ontario, Canada, and the Pathfinder Trailer Company in Elkhart, he had the largest production capacity of any company in the industry. When he purchased the Royal Wilhelm trailer company in Sturgis, Michigan, and opened a plant in Christchurch, New Zealand, he became the first trailer builder with facilities on two continents and in three different countries. He also opened a wholesale distributor company in Sweden. By the start of 1939, only three years after beginning to build trailers, Schult had supplanted Covered Wagon as the largest trailer manufacturer in the world.

Like Harold Platt, Wilbur Schult became very active in national association work promoting the industry in general. In 1940, he became national chairman of the TCMA and was the director of the first national trailer show in 1940, a position he held for the next fourteen years. In 1938, he built a luxurious forty-foot fifth-wheel rig for New England publisher Myron Zobel that included a custom matching semi-truck tow vehicle. Labeled the Continental Clipper, this one-of-a-kind

Opposite, top: A mid-1950s Platt camper trailer. This is one of the small travel trailers built by pioneer Harold Platt, in addition to the mobile homes that were his primary product by this time. *Courtesy of Al Hesselbart.*

Opposite, bottom: A 1950s Platt RV. This is an example of the travel trailers built by Harold Platt before shutting down his production. *Courtesy of Al Hesselbart.*

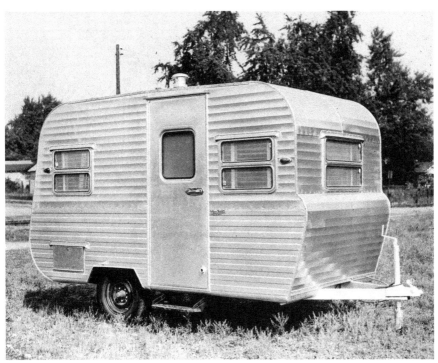

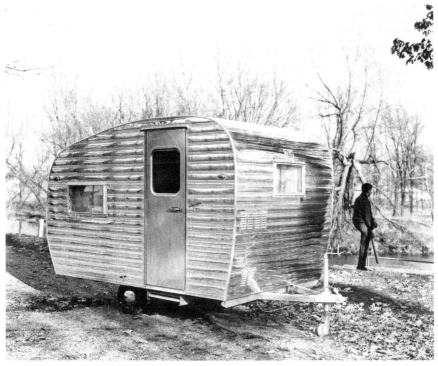

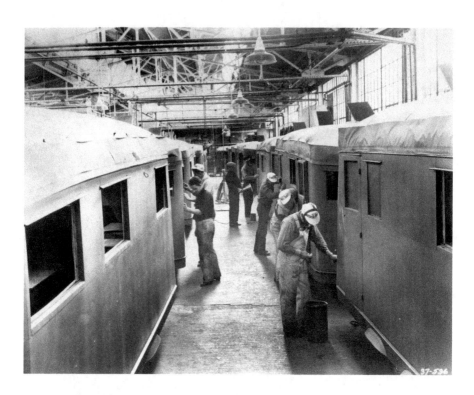

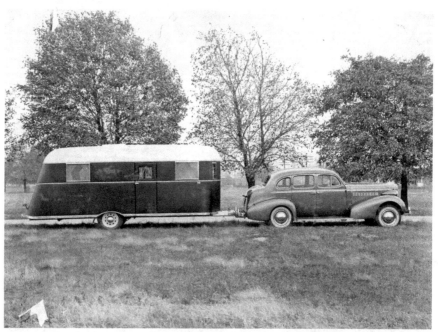

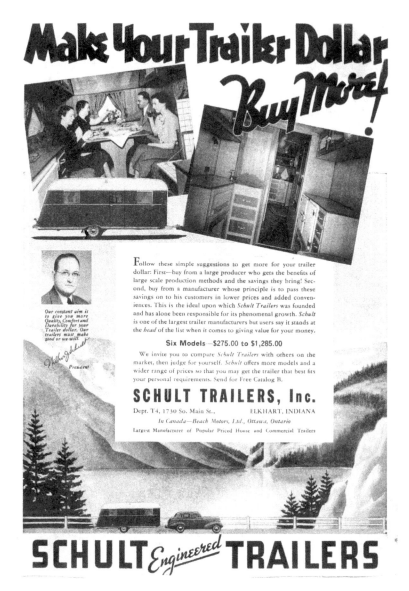

A 1937 magazine ad for Schult trailers showing a parallel to today's RV advertising. *Courtesy of the RV/MH Hall of Fame.*

Opposite, top: The Schult factory assembly line. This view shows the compact construction system that allowed Schult to become, at one time, the largest trailer builder in the United States. *Courtesy of Professor Carl Edwards.*

Opposite, bottom: A 1938 Schult Deluxe ready for travel. *Courtesy of the RV/MH Hall of Fame.*

RV became so world famous that Zobel sold it to King Farouk of Egypt in 1945 after touring the United States for seven years. A book, *The 25 Carat Trailer*, extols Zobel's exploits with the Clipper. Farouk made a few modifications and, for many years, used the outfit as a base for hunting safaris throughout Africa. The commonly accepted story is that Zobel sold the Continental Clipper to the king for the same price that he had paid for it in the '30s.

In 1939, Clem Whiteman began building Whiteman trailers in the same Mishawaka factory where Stanley's Ideal Trailer Company had built the Stage Coach Trailers. Whiteman trailers quickly became

Opposite, top: The interior of the Continental Clipper luxury custom fifth-wheel trailer built by Schult in 1938. *Courtesy of the RV/MH Hall of Fame.*

Opposite, bottom: The 1939 RV show in Chicago. As the nation healed from the Great Depression, trailer shows became very popular entertainment. *Courtesy of Professor Carl Edwards.*

Below: A 1938 Continental Clipper. This is the custom-made luxury fifth-wheel trailer built by Schult in the late 1930s. *Courtesy of the RV/MH Hall of Fame.*

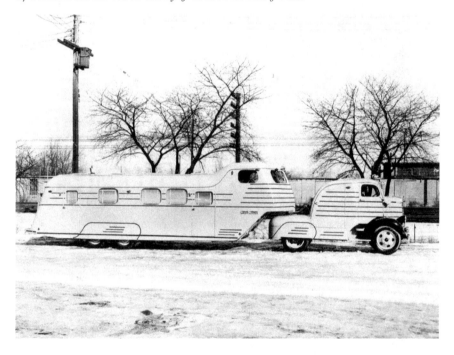

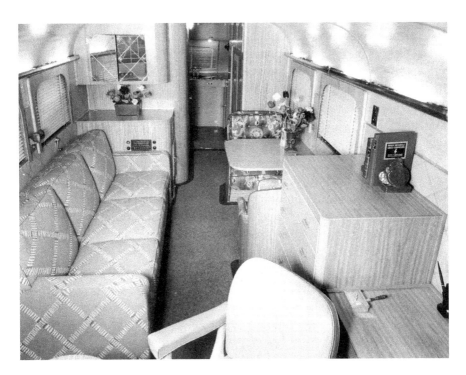

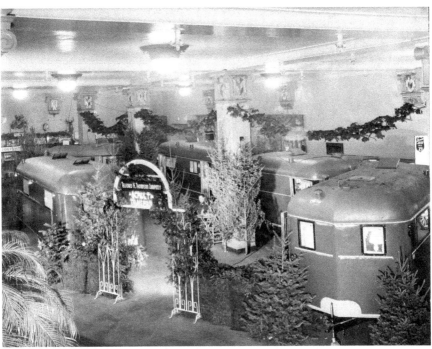

successful enough that the company was sold to Bill Rivers in early 1941. Whiteman trailers were fairly upscale compared to most others of the time. They were base priced at $895 when most brands had entry models in the $400 to $500 range. Shortly after the acquisition by Rivers, the Mishawaka factory burned to the ground, destroying all plans, tools and inventory. Not to be defeated, Rivers moved his operation to an old paper mill near the Elkhart River in Elkhart, where he renamed the company LaSalle Coach. LaSalle became a popular coach in the postwar years and into the '50s and '60s, when it evolved from travel trailer construction into an early mobile home builder.

In 1940, H.L. Spencer started Liberty Coach Company in the small town of Bremen, just south of Mishawaka. Liberty grew rapidly in the short period before material rationing shut down most trailer company growth, and Spencer opened a second production facility in Syracuse. After the war, Spencer moved his headquarters to Goshen, where it continues today as a respected builder of manufactured homes under the third-generation leadership of the Hussey family, who purchased it from Spencer in 1958.

During the war, when rationing limited trailer manufacturers' access to supplies and materials, Schult was able to continue in full operation by building a wide range of military equipment for the U.S. Army. He built special bus-like trailers for prisoner of war transport service and special trailers to be recovery vehicles for the large gliders used to deliver paratrooper squads into battle zones. He also produced trailers to be rolling morgues to respectfully return the bodies of soldiers killed in battle to the rear lines and facilities and converted Ford sedans into "woody" field ambulances. These morgue trailers became bluntly identified as "dead haulers." During the war, Schult developed the first multi-section units, where two eight- by twenty-four-foot trailers were fitted together into one "doublewide" living unit. These were assembled as housing for workers on the top-secret Manhattan Project at Oak Ridge, Tennessee. His work with the government's military needs kept over six hundred employees working around the clock during the war.

One of the most amazing parts of the story of the early days of the recreational vehicle industry was the fact that while being fierce competitors, the early manufacturing geniuses, not only from Elkhart but nationally as well, recognized that they were cogs in a much larger wheel—that being the creation of an entire new industry segment. They seldom hid trade secrets from one another but shared ideas that worked,

A World War II prisoner transport vehicle. These vehicles were rolling jails used to deliver German POWs to secure holding facilities. These types of military vehicles allowed RV makers to stay in operation during the war. *Courtesy of the RV/MH Hall of Fame.*

A World War II Schult glider recovery trailer. These trailers were made to recover military gliders after they had released their load of paratroopers behind the front line but had no power to return to base. *Courtesy of the RV/MH Hall of Fame.*

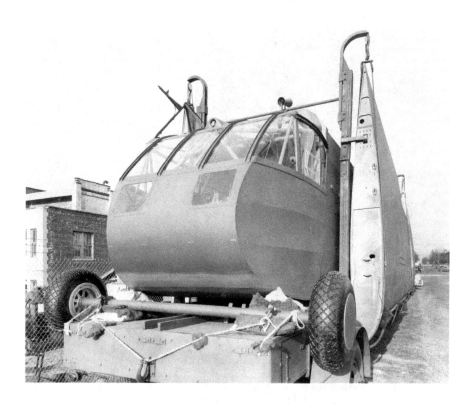

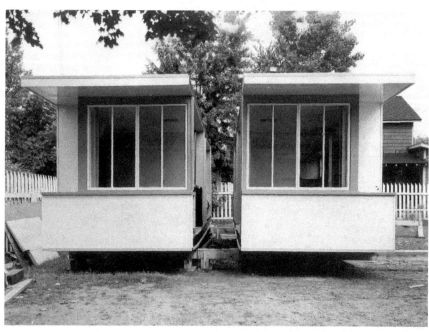

and some even wrote columns in early trade magazines advising their competitors of new tricks of the trade. Part of the development of today's multibillion-dollar RV industry came from the fact that many of these very early trailer pioneers recognized that they were part of something bigger than themselves and consciously worked to grow it.

Opposite, top: A glider trailer loaded. This shows how the wings were removed and the aircraft were transported. *Courtesy of the RV/MH Hall of Fame.*

Opposite, bottom: A Schult 1943 two-piece home. This shows how an early trailer builder developed what evolved into double-wide mobile homes. *Courtesy of the RV/MH Hall of Fame.*

CHAPTER 3

The Postwar Growth Years

A s soon as the war was over, in 1945, more trailer manufacturers began to appear in the South Bend–Elkhart area. The twenty years immediately following the end of World War II was probably the period of the most explosive growth in the history of the industry. Indiana's involvement in the RV industry grew from around fifty manufacturers when the war began to around three hundred, most in the Elkhart–South Bend area, by 1970. Dealers and suppliers grew to over five hundred in the same period.

In 1945, Elmer Weaver started the Yellowstone Trailer Company in the town of Wakarusa. Weaver's trailers featured residential apartment–style kitchen ranges and refrigerators instead of the modified camping appliances in common use at the time. Yellowstone grew to be recognized as one of the finer RV manufacturers of the '50s, '60s and '70s, and the name continues today as a brand in the Gulfstream Coach family. Having sold Yellowstone after just a few short years, Weaver relocated to Florida and started the Fleetwing trailer company. In 1958, he returned to Wakarusa with his Fleetwing Traveler brand of small twelve- to seventeen-foot camper trailers. In 1971, the Pletcher family of Elkhart bought Fleetwing and expanded it into a full-line RV manufacturer. Unfortunately, Fleetwing fell victim to the disaster brought about by the late 1970s fuel shortages, astronomical interest rates and general economic collapse, all of which nearly destroyed the entire RV industry.

The Cree Coach Company was founded in 1945 in the Michigan town of Marcellus, not very far north of South Bend. Cree Coach was created

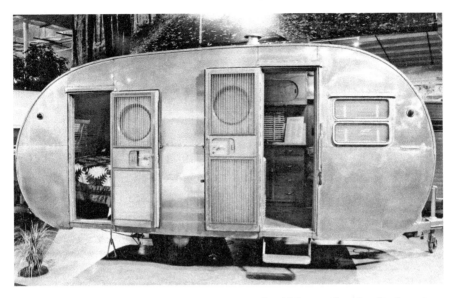

A 1954 Yellowstone. In the early '50s, Yellowstone built a higher quality of trailer featuring residential-type appliances. *Courtesy of Al Hesselbart.*

as one of the very early builders of slide-in camper caps for pickup trucks. These were sold as the Cree Pickup Truck Coach and were first marketed at an early trailer show at Chicago's Navy Pier in 1945. The Cree Coach was sold as both eight- and ten-foot models and was available on a heavier frame and designed so that wheels could be added to allow it to be towed as a trailer behind an automobile as well as carried by a pickup truck. In these immediate postwar years, most citizens were not familiar with the concept of pickup trucks as family transportation and certainly had no idea of mounting a very small house in the truck bed to go camping. In the postwar period, when returning GIs were looking for inexpensive means of family recreation, Cree was one of the first companies to make the truck-based camper, which introduced the American public to the possibility of enjoying the great outdoors in a portable house that could be removed from their vehicles, returning the truck to the utility of daily use. The Cree product lineup that evolved into a full line of trailers, as well as pickup coaches, was produced from 1945 until 1992.

Also in 1945, Stewart Gardner, who had worked with Milo Miller at Sportsman and Elcar in the early 1930s, started the Stewart Coach Company in Bristol. Stewart Coach was a respected and successful brand through the '50s, '60s and '70s. It was best known as a builder of fine

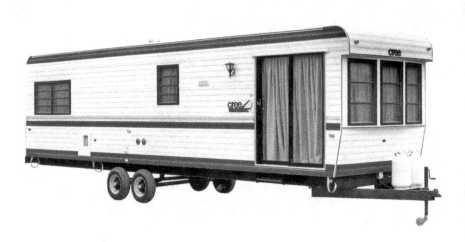

The Cree RV. This is a modern version of the historic Cree Coach. *Courtesy of Al Hesselbart.*

mobile homes but continued to manufacture a line of travel trailers through its history.

In 1946, Solomon Kropf started building trailers in Goshen. Through the years, Kropf Industries has continued with many product changes. Leaning at first toward the larger mobile home–type units, it evolved into travel trailers and fifth-wheel trailers and by the 1970s had focused primarily on the park model RVs designed to be permanently or semi-permanently placed in campgrounds. Solomon's son Bob led the park model trailer production and was instrumental in the formation of the national Recreational Park Trailer Industry Association (RPTIA), which he led as president for fifteen years. RPTIA has evolved into becoming a part of RVIA, the national Recreation Vehicle Industry Association. Kropf Industries continues today as one of the nation's largest manufacturers of park trailers under the leadership of the third and fourth generation of Solomon Kropf's family.

In 1946, Franklin A. Newcomer started Franklin Coach in Wakarusa with Paul Able as a partner. Franklin Coach became the first of three well-known trailer brands begun by Newcomer over the next ten years. In the early '50s, Newcomer sold his majority interest in Franklin to his partner, Able. Franklin Coach survived until 2007, when a huge tornado struck the

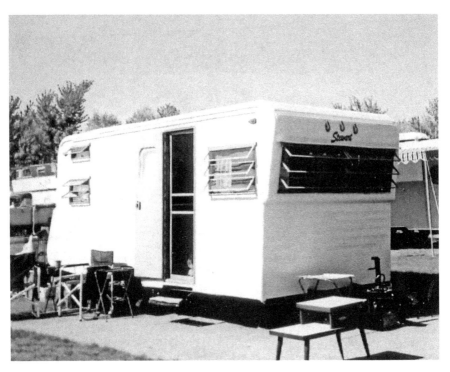

A 1964 Stewart RV. Stewart Coach made advanced design travel trailers in the years before the oil embargo disaster of the '70s. *Courtesy of Al Hesselbart.*

Nappanee complex where they were built, totally obliterating all signs of the company and leaving nothing but the bare concrete slabs where the large factory buildings had stood. In 2010, Franklin Coach was resurrected at another facility in Nappanee and began producing park model RVs. In 1954, Newcomer started FAN Coach, using his initials for its identity. When FAN quickly became successful, Newcomer left it in the control of his sons Keith and Donald and started Monitor Coach as his third RV brand. In the early 1960s, he bundled the FAN and Monitor companies and sold them as a package to the W.R. Grace Company, which made agricultural chemicals and, like many diverse companies with available cash, was electing to enter the exploding RV industry. Grace proved totally ill equipped to work in the RV industry, and in 1968, Franklin and his wife, Maxine, repurchased both failing companies for a reported ten cents on the dollar to attempt resurrection. When both again became solvent under his brilliant leadership, Franklin separated them and sold FAN, which was now operating in LaGrange, to Coachmen Industries and Monitor

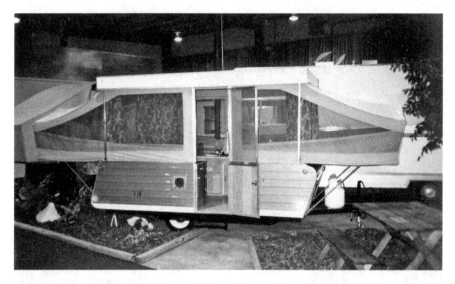

A 1968 Jayco tent camper. This is one of the original campers built by Lloyd Bontrager at the startup of Jayco. *Courtesy of Al Hesselbart.*

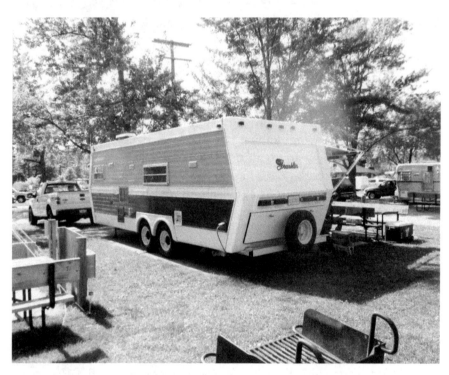

The Franklin Travel Trailer. This would be one of the fine RVs built by Franklin Coach in the years before the 2007 tornado disaster. *Courtesy of Al Hesselbart.*

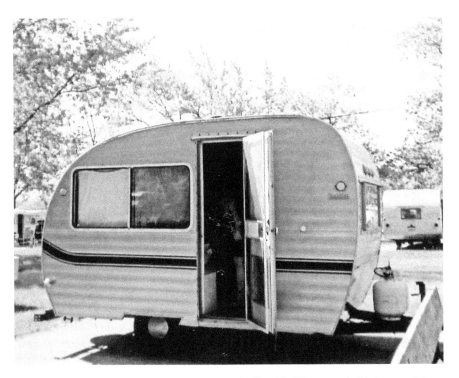

A 1958 Monitor. This is one of the trailers built by Franklin Newcomer's third successful company. *Courtesy of Al Hesselbart.*

to Holiday Rambler, whose dynamic growth in Wakarusa had completely surrounded the neighboring Monitor facilities. Both companies absorbed the unique models and designs of their acquisitions into their own brands, and FAN and Monitor ceased to exist as individual brands in the early 1970s, while many of their popular features continued for many years on Coachmen and Holiday Rambler models.

Through the late 1940s and the 1950s, M.E. "Gene" Raker of Fort Wayne built a combination of travel trailers and some of the early "oversized" units intentionally made as mobile homes. Raker's Peerless Trailer Company was one of the pioneers of using prefinished aluminum siding on his trailers, not only dropping the fabric, Masonite and wooden exterior skins appearing on earlier trailers but also avoiding the need to paint the coach after it was constructed by using pre-finished skins.

In 1950, Victor Coach, a small RV trailer builder in Bristol, purchased a few bare rail truck chassis (frame and engine with no cab or body) and designed and built what were probably the start of today's type-A motor

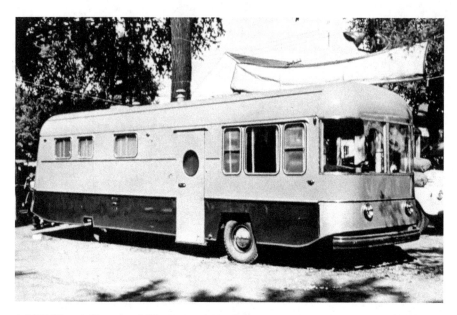

A 1950 Victour "housecar." Victours were the first type A–style coaches. *Courtesy of Professor Carl Edwards.*

home industry. Earlier coach builders had mostly converted existing highway buses into RVs, but the Victour housecar was entirely built, both inside and out, by an Indiana RV company on the Detroit-supplied chassis. While only sixteen or eighteen Victours were made, they set the stage for the giant type-A motor home industry of today. One of the original Victour owners was world-famous golf champion Sam Snead, who traveled to many tournaments in his mobile apartment. Transportation of the bare chassis from factory to assembly plant was a new challenge, and stories were told of drivers taking a train to Detroit carrying rain gear and an orange crate, which was to become a temporary driver's seat for the two-hundred-mile return trip to Bristol totally unprotected from the highway or the elements on the open chassis.

As the more than fifty trailer companies working in the Elkhart–South Bend area boomed in the late 1940s, Illinois trailer dealer Herb Reeves Jr. sold his store and moved to Elkhart in 1951 to open a distributorship for the new liquid propane gas–burning Florence Stoves, which were rapidly replacing the Coleman white gas–fueled stoves that had been the industry standard since the 1930s. Herb's father worked with the Florence Stove Company and had advised him of the explosive demand for the

new propane-fueled ranges in the trailer industry. Reeves's stove business boomed, with some of the larger manufacturers ordering stoves by the railcar load. In 1958, he sold the distributorship and acquired the rights to the 1930s Detroit, Michigan–based trailer brand Covered Wagon, which had been the largest name in the industry in the years before World War II but had been inactive for many years, and began building what he advertised as the "Oldest Name in Trailers." In the early 1960s, Reeves started several other trailer brands, including Easy Traveler, Bon-Aire and DeCamp. One popular feature that he pioneered for RVs is the space inside the rear bumper where the sewer hose can be stored. With several trailer brands, he became very active in both the state and national associations for trailer builders and served as the director of the Indiana trailer manufacturers' first statewide trailer show.

In 1968, Reeves sold his trailer companies and moved his base of operations to nearby Jones, Michigan, where he opened the Arrowhead Park Campground, entering his fourth different division of the RV industry. From his campground, Herb Reeves was the founder and first chairman of the

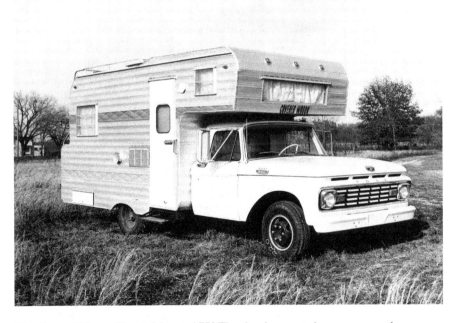

The Covered Wagon Chassis Mounted RV. The chassis-mounted campers were the predecessor of the type-C motor home. *Courtesy of the RV/MH Hall of Fame.*

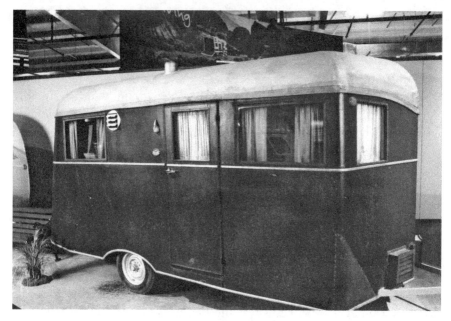

A 1935 Covered Wagon, one of the type of trailers that would have been sold by Wilbur Schult's early retail store. *Courtesy of Al Hesselbart.*

Michigan Association of Private Campground Operators (MAPCO). In the association, he developed the first statewide campground and RV service directory for campers to use in researching available campgrounds and their facilities. This touted guide became a pattern for many of the campground guides used by RVers today. In the early 1980s, Reeves entered his fifth different segment of the RV industry when he became the executive director of the Elkhart-based RV/MH Hall of Fame, an organization to recognize and honor the industry's key leaders, which he operated for many years out of his home. That institution has evolved into the large world-famous RV/ MH Hall of Fame and Museum in Elkhart today.

In 1951, Julius Decio, an Elkhart tavern keeper, began building a few trailers in a garage behind his tavern on Sixth Street in the Italian community on the south side of Elkhart. Decio's trailers proved to be quite popular, and as Skyline Coach, his company began to grow. In 1952, Decio's son Arthur graduated from DePaul University in Chicago and joined his father in the growing trailer manufacturing business.

Through the 1950s, Arthur Decio proved to be much more enthusiastic than his father about growing the trailer company, and Julius evolved back

into spending most of his time operating the neighborhood tavern. Through the late 1950s, with Arthur's enthusiasm and genius for the trailer business, Skyline Coach rapidly grew, building a combination of recreational vehicles and manufactured homes. In 1956, Arthur was named CEO, and in 1960, he took the company public as Skyline Corporation. Under Art, it continued to grow and, by the early 1960s, came to be recognized as one of the largest trailer manufacturers in the country. In 1961, Julius Decio was recognized as the patriarch of a leading company in the transportation sector of American industry with an invitation to participate in John F. Kennedy's inaugural ball. In 1965, Arthur Decio became the

Arthur J. Decio led and built Skyline Corporation for over fifty years, creating one of the largest, most respected manufacturers in the trailer industry. *Courtesy of the RV/MH Hall of Fame.*

first RV company executive to have his face on the cover of *Time* magazine, in relation to a story on self-made millionaires under the age of forty.

In the early years, Skyline built a combination of large and small "house trailers," which were mostly identified as mobile homes, but several models were more the size of travel trailers. After going public, Skyline quickly grew by acquiring the Homette, Buddy, Layton and Academy brands and began to diversify by spreading its plants around the country to be closer to the customer base. In 1966, Art Decio built his first dedicated RV factory and separated the company into separate divisions for mobile homes and RVs. Skyline grew to have twenty-five production plants spread throughout the country: nineteen building the larger mobile homes and six building RVs. The RV division established itself and built travel trailers and fifth-wheel trailers under the Nomad, Layton, Aljo and Rampage brand names.

Arthur Decio has always been recognized as a very conservative business leader and operated his company to grow slowly and steadily and to keep

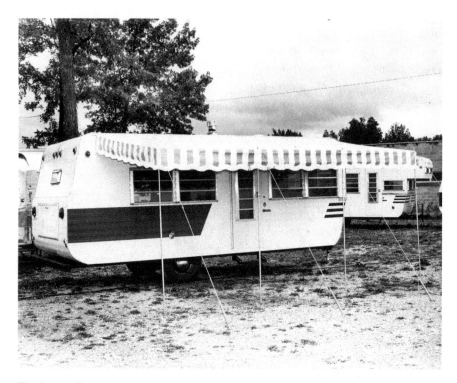

The Layton Travel Trailer. Skyline Corporation's Layton brand trailers were very popular in the '70s. *Courtesy of the RV/MH Hall of Fame.*

his finances balanced so as not to create serious debt. As a result of his financial plan, Skyline was unique in the industry in being able to survive the disastrous 1970s oil embargo crisis without suffering even one year of loss.

Skyline maintained a key position in the trailer industry for forty years, until the housing economic crisis of the 1990s and the introduction of new, dynamic companies into the industry reduced its industry status. It continued to operate at a respectable level until the financial disaster of 2008–09 created a major dip in the nation's RV market and nearly stopped Skyline's RV sales. In 2016, Skyline sold its entire RV division to Evergreen, and it continues as an exclusive manufactured housing company.

Through his sixty-plus-year highly successful career in the trailer industry, Arthur J. Decio has earned a reputation for an independent and unique way of doing business. His board of directors always was made up of non-RV business leaders, so he was not affected by an industry thought pattern. After only a few years of building motorized RVs, he discontinued that branch,

saying he did not want Detroit telling him how to run his company. He earned a reputation as an extremely generous philanthropist, supporting both local and national institutions of many types, from homeless shelters and hospitals to universities and the Salvation Army, of which he served as national chairman for many years.

In 1953, Elkhart resident Richard Klingler and his Klingler Products Company began creating trailer parts in an old chicken coop and assembling his trailers outside in his driveway. The original design of Klingler's trailers deviated from the common "canned ham" shape popular at the time, with a square, boxy silhouette, a flat roof and squared-off ends. One story says that when his father suggested over breakfast one day that he would need a catchy name for the trailers, he looked into the drive, and seeing his father's Oldsmobile Holiday model and his own Nash Rambler, he put the names together, creating Holiday Rambler. Through the early years, he also made Holiday Traveler and Holiday Vacationer models, but the Holiday Rambler was so successful that he eventually changed the name of his company from Klingler Products to Holiday Rambler Corporation, and the other models disappeared from circulation. Holiday Rambler relocated from Elkhart to Wakarusa in 1959. In 1961, Klingler pioneered aluminum structural

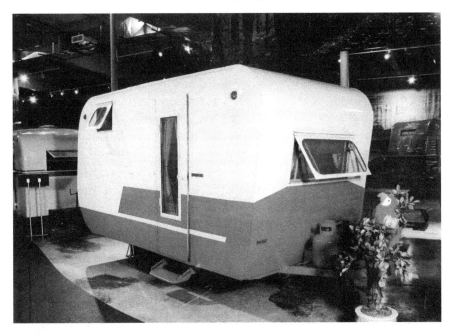

A 1954 Holiday Rambler. This is one of the first trailers built by the iconic company in its first year of production. *Courtesy of Al Hesselbart.*

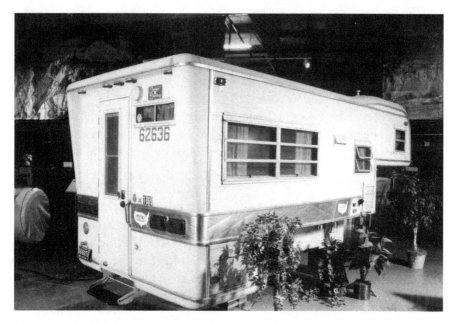

A 1969 Holiday Rambler truck camper. This was one of the first comfortable truck campers that was not a simple shelter shell. *Courtesy of Al Hesselbart.*

framing, greatly reducing the weight of RVs with his Alumalite designs that replaced the traditional wood body frames. The aluminum framing made for lighter and stronger frames and continues to be used today as an industry standard.

As Holiday Rambler grew through the 1960s, its lineup expanded into slide-in truck campers, fifth-wheel trailers and motor homes. Klingler developed the unique Holiday Rambler Motovan, a sixteen-foot-long slide-in camper, to be placed in an eight-foot pickup truck bed and extending an additional eight feet out the back. This extraordinary camper required an additional axle and set of wheels to prevent upending the truck with its extended weight. In his motor homes through the years, Klingler pioneered tag axle design with a supplemental second rear axle and wheels and kitchen slide-outs, making his coaches much roomier.

In addition to his Holiday Rambler RVs, Klingler developed subsidiaries that have contributed greatly to the RV lifestyle. He started Parkway Distributors, which grew into a major national retail outlet for all kinds of aftermarket parts and supplies to make the RV consumer safer and more comfortable. Parkway Distributors has been merged into today's large Stag-

Parkway distributor company. His Utilimaster division, a builder of small delivery van–type vehicles, has grown to win contracts to build the huge fleets of delivery trucks for both UPS and Federal Express parcel delivery companies, along with several other food and parcel delivery firms.

In 1986, to facilitate his retirement from the RV industry, after several unsuccessful attempts to organize an employee buyout of his company, Klingler sold Holiday Rambler Corporation to the Harley Davidson Motorcycle Company. After ten years of less than stellar success with its entry into the RV world, in 1996, Harley Davidson sold Holiday Rambler to Oregon-based Monaco Coach, another upscale motor home manufacturer that was in the process of acquiring several brands of coaches, including the National, Beaver and Safari brands, in addition to Holiday Rambler. When the national economy went sour in 2009 and 2010, the overextended Monaco Corporation was sold to the Navistar (International Harvester) Company. In 2012, Holiday Rambler returned to its Indiana home base when the Monaco holdings were purchased from Navistar by the American Recreation Group ARG, a Decatur-based investment company that held the motorized brands of the bankrupt California-based Fleetwood Enterprises. In 2013, the production of Holiday Rambler RVs that had remained in Wakarusa through the various ownerships was relocated to the huge Decatur complex, ending its seventy-year presence in Elkhart County.

In 1953, the Elkhart-area manufacturers, along with the Indiana RV and Mobile Home Association, created the annual Elkhart Trailer Super Show, which was soon joined by manufacturers from throughout the nation and by 1958 was recognized as the country's largest trailer show. The Elkhart Show outgrew the city's available space and, in 1962, was relocated to the campus of Notre Dame University in South Bend, where for many years it continued to be recognized as the country's largest. A smaller version of that show continues today, still sponsored by the Indiana state RV association but without the manufactured housing industry involvement. It has returned to its original roots in Elkhart. In addition to the RV Supershow in August, today the Recreational Vehicle Indiana Council hosts shows in Indianapolis, Fort Wayne and South Bend.

In the mid-1950s, Pat Spiker began to build small Arrow brand trailers in Nappanee. His most popular model, the Arrow Little Chief, is highly popular with vintage camper owners today. At the same time, Spiker's brother began to market the short-lived Arro (no w) brand of chassis-mounted motor homes, also made in Nappanee. Arrow trailers were made until the first oil crisis of the early '70s.

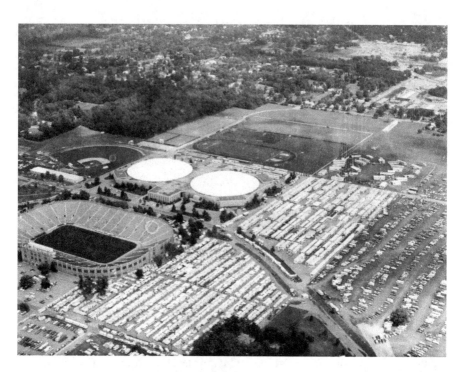

The industry giant California brand Shasta created a manufacturing plant in Goshen in 1958. At the time, Shasta was the nation's largest trailer builder and was growing rapidly. It needed to have an eastern production source to better serve its eastern dealers, as the expense of transportation from the West Coast was prohibitive. Shasta continued to grow, and in the mid-1960s, the company was acquired by Elkhart-based Coachmen Industries, which closed the California plants and moved all production to the Elkhart-Goshen area. This brought the second-oldest name in the trailer industry (after Airstream) to Indiana, with Shasta having been founded in 1941.

Opposite, top: The 1968 Trailer Super Show at Notre Dame University. In the late 1960s, this became the largest trailer show in the country and encompassed both RVs and mobile homes. *Courtesy of the RV/MH Hall of Fame.*

Opposite, bottom: A 1960s Shasta Motor Home, one of the early motor homes made by the iconic trailer company. *Courtesy of Professor Carl Edwards.*

CHAPTER 4
The Growth Boom Begins

With the start of the 1960s, the trailer industry began to take its place as the primary source of jobs in the Elkhart area. Hundreds of small companies and many major players popped up throughout the Elkhart and South Bend area over the next fifteen years. When the huge Studebaker auto company went out of business in South Bend in the early 1960s, many of its workers found jobs in the booming RV plants. As the baby boom families

became active and proved to love the concept of inexpensive outdoor recreation, the demand for affordable camping vehicles, especially trailers and slide-in pickup truck campers, grew exponentially. The popularity and use of motorized campers came later, toward the end of the '60s, as the earliest motor homes were mostly prohibitively priced.

Ed Enochs introduced his Westward Coach Manufacturing Company in Bristol in 1960, producing truck campers, travel trailers and a few chassis mount–style motor homes, which were the predecessor to the type-C coaches we know today. His campers included several unique models, including the first bunkhouse-style design that offered separate beds for a whole family. Enochs introduced his Mustang line of campers, for which he received an Indiana trademark in 1962 that included his Mustang name and charging horse logo. A federal trademark was added in 1967. Unfortunately, the Ford Motor Company had, in 1964, introduced an automobile with the same name and similar logo and challenged Westward Coach's rights to the

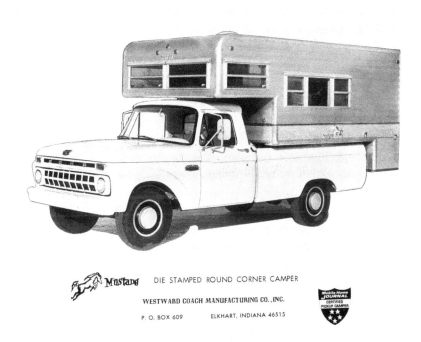

Mustang DIE STAMPED ROUND CORNER CAMPER

WESTWARD COACH MANUFACTURING CO., INC.

P. O. BOX 609 ELKHART, INDIANA 46515

Above: A Mustang Truck Camper. This is one of the early slide-in campers made by Westward Coach in the 1960s. *Courtesy of the RV/MH Hall of Fame.*

Opposite: A 1968 Blazon Camper. This is an example of the popular campers made by the hundreds of manufacturers in Elkhart in the '60s. *Courtesy of Al Hesselbart.*

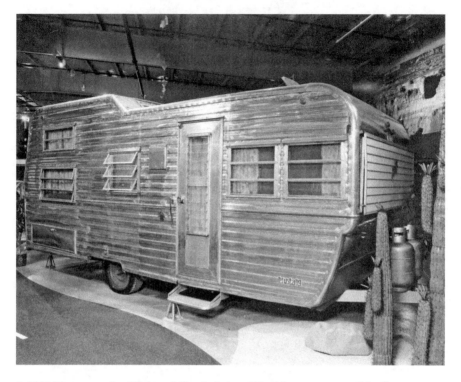

A 1966 Mustang trailer. Westward Coach designed the Mustang as one of the first bunkhouse-style campers providing multiple beds. *Courtesy of Al Hesselbart.*

identity. The resulting legal tug-of-war resulted in the bankruptcy, closing and disappearance of the much smaller Westward Coach company and its entire line of campers.

In 1960, Elkhart resident Bob Barth started the Bee Line trailer company to build the small affordable "canned ham"–style campers that were the most popular at the time. Bee Line became successful quickly and grew to be a popular brand in the most affordable segment of the industry. Barth shortly had a different idea for an RV product, and in 1963, he sold his interest in Bee Line and relocated to Milford, where he started the Barth RV Company, using his own name as the company identity. The Barth concept was quite different from most RV companies of the time, building a limited number of very high-quality, custom-made, all-aluminum trailers. His idea of targeting exclusively the far upper-priced market proved workable, and Barth RV established itself among the finest trailer makers in the country. In 1968, Barth again sold the growing successful company bearing his name to

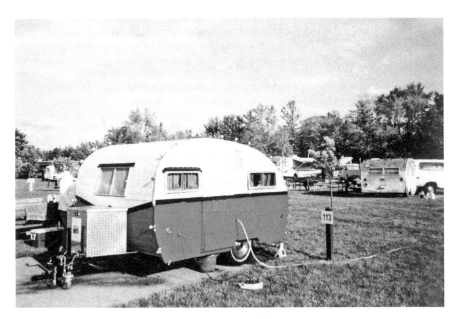

The BeeLine Camper. This is one of the earliest trailers made by Bob Barth. *Courtesy of the RV/MH Hall of Fame.*

Mike Umbaugh, an investment banker without RV experience who had a dream of joining the slowly growing list of motorized RV builders.

Under Umbaugh, the Barth company kept true to the model of exclusively high-line RV products but quickly added a line of motor homes that was among the finest available anywhere in the country. These were not the expensively converted highway buses but totally custom made from the ground up. In the early 1970s, Barth was one of the first manufacturers to offer diesel engines in its coaches, and a few years later, it was one of the first to go to the "pusher" design, placing the engine in the rear rather than in the front of its products. Another popular innovation credited to Barth is the use of a backup camera with a monitor at the dashboard so the driver can clearly see what is behind such a large vehicle. When the mid-'70s economic crisis hit the RV industry, virtually eliminating the demand for motor homes, Barth was able to survive by converting a portion of his production to the manufacture of specialized commercial vehicles. Through the second half of the '70s and into the early '80s, in addition to its RV line, Barth built a combination of library bookmobiles, mobile X-ray labs, medical and dental clinics, mobile TV production units and industrial display coaches. Barth's credibility in the mobile medical field was enhanced when singer

Paul Simon recruited the company to build a special unit to be financed by Cornell University to serve the very poor in New York City as a mobile, curbside medical facility. Barth continued to build its exclusive upper-class RVs, including a few innovative propane-powered coaches, until it closed its doors in 1998.

In 1963, brothers Ora and Edward Miller had an idea for a folding tent trailer with a lightweight aluminum roof. In 1964, they began producing their Wheel Camper brand trailers in an old chicken coop near the small southwest Michigan town of Colon. The Millers' most popular feature was a unique complete kitchen built into an inside counter that pulled out from the side like a dresser drawer. Identified as the Kwickitchen, it allowed the camp cook to prepare meals outside the trailer, much closer to where the family was enjoying the camping experience, instead of out of contact and hidden inside. It also brought cooking odors outside the trailer. Their business grew rapidly, and very shortly they were required to abandon the Colon chicken coop and move to a larger factory in the nearby town of Centerville. By 1966, they had expanded their line to seven different models, and by 1968, the Wheel Camper trailers were being distributed coast to coast and the lineup had expanded to eleven models. In 1970, the Millers introduced a line of conventional travel trailers and some fifth-wheel trailers that they identified as Truk Travelers. That year also saw the introduction on their top-of-the-line tent camper models of their Air Lift Top, where by pushing a button, the top was raised without effort pneumatically. After an explosive eight years of growth, the Millers sold Wheel Camper to Coral Industries in 1972, but the disaster that was the '70s was already beginning to affect the RV industry. New management and new models were not enough to keep going, and by the end of 1973, Wheel Camper was bankrupt and had ceased all operations.

In 1964, three brothers with varied backgrounds decided to start a trailer company. Tom, Keith and Claude Corson each had experience that was needed to put together a successful venture. Tom was an accountant working as a "Friendly Bob Adams" for the Associates Finance Company. Keith was an engineer, and Claude was a manager for an already successful RV manufacturer. Calling themselves the "coach men," the Corson brothers founded Coachmen Industries, which was destined to grow into one of the largest RV manufacturers in the country. They did start slowly, with their first-year production equaling fewer than one hundred products. In that year, they built and sold twelve travel trailers, one slide-in truck camper and eighty utility pickup truck caps. From this rather inauspicious start, Coachmen

Industries grew through acquisition and origination to become a multi-level RV company recognized at one time as the third-largest manufacturer of recreation products in the United States. The brothers built a full line of RVs under the Coachmen name, and as they grew, they acquired the Viking Recreational Vehicles line of folding tent campers in 1968, locating it in the Centerville, Michigan facilities that had been abandoned with the closing of the Wheel Camper trailer company, and grew it into one of the nation's largest makers of tent campers. Viking also built a line of boats that Coachmen divested after a short while to the makers of Chris-Craft boats. Coachmen bought the California-based Shasta Trailer Company, adding greatly to its travel trailer line, which was especially attractive on the West Coast. The company purchased the Georgie Boy Company, an Edwardsburg, Michigan producer of motor homes, greatly increasing its presence in the motorized RV field, and the Sportscoach brand in 1981, bringing a high-line motor home into its stable. Sportscoach motor homes were designed for full-time living and equipped for a long-range travel lifestyle.

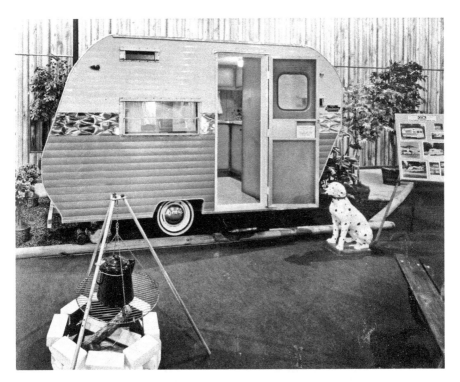

A 1964 Coachmen Cadet. This was the very first trailer built by the industry giant when it first started to build trailers. *Courtesy of Al Hesselbart.*

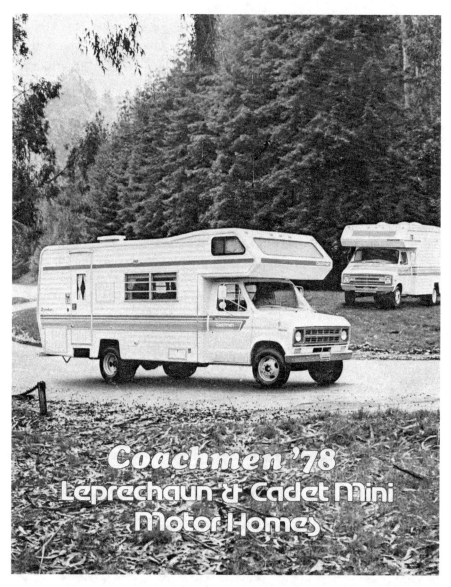

A 1978 Coachmen Leprechaun brochure showing early marketing of the longest-running type-C motor home model. *Courtesy of the RV/MH Hall of Fame.*

The company originated what it called a "The Buck Stops Here" warranty where, instead of requiring customers to deal with each component manufacturer for repairs, Coachmen took responsibility for the entire RV and dealt with the appliance and part manufacturers itself. This proved

so popular that soon it became a standard throughout the RV industry. Coachmen went public in 1969, only five years after its somewhat slow beginning, and joined the Fortune 500 list of America's largest corporations in 1983.

Coachmen also diversified into the supply side of the RV industry with the creation of Coachlite Supply, a full-line marketer of aftermarket materials to the RV consumer. It also opened Prodesign Products, a company to thermoform plastic products such as holding tanks, raised roofs, running boards and vehicle ground effects products and other plastic items for the RV and vehicle manufacturers. Prodesign became a leading manufacturer of aftermarket fiberglass running boards for pickup trucks and passenger vans.

As Coachmen Industries evolved, Tom became the CEO and chairman; Keith was president and managed the operations; and Claude, who had originated the concept of joining together to start up the company, eventually left to develop his own ventures. Tom not only looked after the finances and marketing of his company but also became very active on the national scene. He served many years on the boards of directors of both the Indiana and national RV associations, chairing several committees of both organizations. Tom Corson was recognized as Indiana Master Entrepreneur of the Year in 1996 with an award co-sponsored by the professional services firm Ernst and Young and the NASDAC Stock Exchange. The award recognized that starting in 1964 with 3 employees producing only thirteen products, his company had grown to employing more than 3,750 workers and producing over

Thomas Corson started Coachmen Industries with his brothers and became a key leader of the RV industry in the '70s, '80s and '90s. *Courtesy of the RV/MH Hall of Fame.*

eighteen thousand units in 1995. In 2008, Coachmen Industries became a part of Berkshire Hathaway's Forest River RV company.

Also in 1964, the Starcraft Recreational Vehicle Company was formed as a division of the Star Tank and Boat Company, which had been started in Goshen by Arthur Schrock in 1903 to build livestock watering tanks and later had added steel and aluminum boats to its product line. Starcraft's folding tent trailer design proved to be among the very first of the modern tent camper style with the beds pulled out from both ends, a hard top and an aluminum screen door on the side. The Starcraft Starmaster trailer proved popular very quickly. One of Starmaster's popular features was a crank-up system for raising the top that was designed by employee Lloyd J. Bontrager, who later left the company to create Jayco.

Arthur Schrock died in 1966, and his son Harold sold the entire company to Bangor Punta, a conglomerate holding company. It became part of Bangor Punta's Leisure Time group. In 1970, Starcraft introduced its Starliner brand of motor homes, which applied many of its popular travel trailer features to motorized RVs. Starcraft continued to thrive and, in 1977, added van conversions to its line of products. In 1984, Starcraft was acquired by Lear Siegler holdings, whose primary products were Lear Jet Airplanes, Smith & Wesson guns and Piper Aircraft. Starcraft was, in turn, acquired by the Brunswick Corporation and then sold to the Starcraft management team, which was unsuccessful in keeping the firm together. The parts were broken up. The camper division was sold to Jayco; the boat division was sold to Harold Schrock's son Doug Schrock of New Paris; and the balance, especially the automotive or van division, was sold to investor Kelly Rose.

In the mid-1960s, the Del Rey Camper Company of Elkhart was started by Bill Overhulser to build some very unique slide-in truck campers with forward-facing seats in the cab-over area with sufficient head room where passengers could sit and ride to watch the road go by as the driver below traveled down the road. Its Sky Deck camper included a third level that provided a bedroom behind the sky lounge cab over and above the lower kitchen and dining area. By 1968, Del Ray was being recognized as the largest manufacturer of slide-in truck campers in the nation. Overhulser is also identified as the inventor of a popular camper lifting jack that continues to be used today, although he never registered or patented it and it is now made by several suppliers.

Ray Bassett and his Parkwood Homes of Bristol introduced a line of entry-level Honey brand RVs in 1968. From 1968 to 1984, they built type-C motor homes exclusively in an Elkhart factory on Hively Avenue. In 1984,

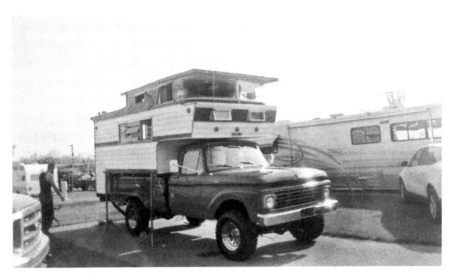

A Del Rey Sky lounge. This is one of the extra-tall truck campers built by Del Rey. *Courtesy of Al Hesselbart.*

Honey introduced an additional line of mid-range type-A coaches that were made until production ceased in 1990.

In 1968, Marvin Newcomer and Marvin Miller left their jobs at another RV manufacturer and created Newmar Corporation in Nappanee, using the combination of their names for its identity. Their goal was to design and build the finest high-quality travel trailers available. In 1971, they introduced the Kountry Aire fifth-wheel trailer, making Newmar one of the first major fifth-wheel trailer manufacturers in the country. Newmar grew rapidly through the 1970s in spite of the economic disaster going on around it. Through the '70s, Newmar earned the reputation of building top-of-the-line luxury travel trailers and fifth-wheel trailers. In 1984, Mahlon Miller (no relation to Marvin)—who had started his RV career as an Amish craftsman in the cabinet shop at Holiday Rambler and grown through the ranks to become president of the company—resigned his presidency of Holiday Rambler and purchased a 51 percent stake in the Newmar Corporation. Mahlon's record of corporate leadership and his genius in developing new features for RVs is especially remarkable given his limited formal education; he only made it through sixth grade in Mennonite schools. Among Mahlon's patents of features to enhance the RV experience for his customers are a roll-down rock guard to protect the front of a trailer while being towed, a powered RV awning and an automatic door step that deploys when the door

Mahlon Miller. An industry genius with a conservative Amish Mennonite background, he is the owner and chairman of Newmar and past president of Holiday Rambler. *Courtesy of the RV/ MH Hall of Fame.*

is opened. Through the 1980s, Newmar entered the luxury motor home market, building a limited number of premium motor coaches. It introduced the Dutch Star and Mountain Aire models, which have continued for years. In 1991, Mahlon Miller purchased the remaining 49 percent of the company, becoming the sole owner. The company enhanced its coaches with the first slide-outs ever available on type-A motor homes and the original flat floor slides for RVs. Through the later years, it discontinued its towable lines and introduced the London Aire, Essex and King Aire premium quality motor homes that are among the very finest made in America. Many Newmar customers, when visiting the Nappanee factory, were amazed to learn that the bearded gentleman in bib overalls helping to wash their RV in preparation for delivery was the company owner and chairman. Miller usually blended in quite easily with the Newmar workforce, which is still very heavily populated with Amish Mennonite craftsmen farmers who report to work by horse and buggy or on bicycles. Today, Mahlon's son Matt leads the company and is very active on the national association board.

In 1968, RV engineer Lloyd Bontrager left his position with Starcraft to start his own RV company in two old chicken coops and a barn behind his home on his farm outside Middlebury. Setting out to build a folding tent camper using a unique crank-up system he had designed to raise and lower the roof, he used his middle name, Jay, for identity and started Jay's Company, or Jayco. He used his favorite bird, the blue jay, for his company logo. Because of the ease of setup that Bontrager's design offered to campers, Jayco quickly became successful. The next year, Bontrager hired his next-door neighbor Allen Yoder, a mortgage

lender at a local bank who was enthused by Jayco's success, to become the national sales manager. Taking advantage of the rapidly increasing demand for campers in the late 1960s, Jayco delivered over 2,000 trailers in 1970 and, partially because of acquisition of another company, 3,500 in 1971. During the early years, Jayco experimented with several unique camping vehicles, including a short-lived product called the Camp-n-Cruise, in which a folding camper was mounted not on an axle chassis but on a pontoon boat with wheels, creating a floating cruisable camper.

Lloyd Bontrager left another company to start Jayco, which grew as the RV industry's largest family-held manufacturer for nearly fifty years. *Courtesy of the RV/MH Hall of Fame.*

In 1973, Lloyd and his wife, Bertha, traveled to Australia to meet a family friend, and together they established a Jayco division producing campers in Australia. At the same time, Yoder and the Jayco staff designed and began to produce a slide-in camper for pickup trucks. As Jayco weathered the first economic crisis of the '70s, Bontrager's eldest son, Wilbur, became active in the company and, like his father, worked in trailer design. He created a domed roof for campers that aided with rainwater runoff and some overhead cabinets to add storage space. The second economic crisis of 1979–81 cost Jayco about 50 percent of its business, but the company survived and at that time introduced its J-Series line of affordable campers that helped it recover quickly when the crisis ended.

The joy of Jayco's rapid recovery from the downturn abruptly ended on Easter Sunday 1985 when Lloyd Bontrager, founder and leader of the company and an avid private pilot, crashed in a storm near Marion, Indiana, while flying back from an RV show in Florida, killing himself and his youngest son, Wendell, who was traveling with him, as well as company research and development worker Nelson Hershberger and his son. Following Bontrager's

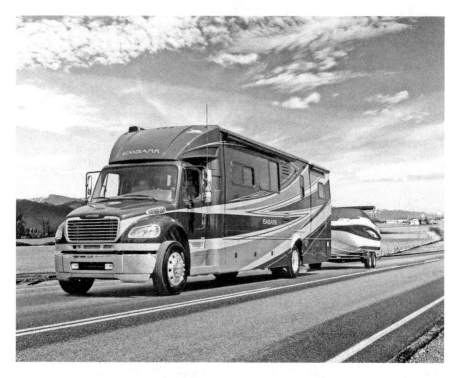

The 2014 Jayco Embark. The Embark is one of today's giant "mobile mansions" based on stretched highway tractor chassis. *Courtesy of Jayco.*

death, the Jayco board of directors appointed Al Yoder Jr. as president of the company. Under Yoder's leadership, Jayco boomed, and by 1987, it was the fourth-largest maker of towable RVs in the country. In 1988, its production had increased from 2,000 trailers in 1970 to 223,000 campers.

In 1990, Jayco purchased two additional manufacturing plants, bringing its production space to exceed 500,000 square feet. By 1993, when Al Yoder retired, Wilbur Bontrager had become chairman of the board. In 2008, Jayco acquired the assets of bankrupt Travel Supreme and began producing high-line diesel pusher motor homes under the Entegra Coach label. In 2015, Jayco has continued to grow under the leadership of Wilbur Bontrager as chairman and his brother Derald as president. It is the largest privately held RV company in the world. In July 2016, Jayco was acquired by Thor Industries, which kept the company management team intact.

In 1969, C.T. Yoder and three partners formed the Carriage RV Company in Millersburg with the goal of producing high-line luxury RVs.

Carriage's introductory product bore one of the company's most important contributions to RV design. The founders built an in-house fiberglass molding department and designed and built one-piece front and rear end panels that eliminated the problem of leakage when towed at highway speeds in the rain that plagued many trailers that used the common aluminum siding for end panels. Carriage followed a philosophy of manufacturing most of its own components other than appliances in order to maintain a close control over the quality of its products. During the thirty years that he led the company, Yoder was not only president but also functioned as the company's primary research and development officer, constantly seeking new and improved features that would make his trailers more attractive and comfortable for his consumers. He was one of the pioneers offering slide-outs on fifth-wheel trailers and designed and built a unique flat floor fifth-wheel where the floor was level from one end to the other with no step up into the bedroom area. The flat floor concept allowed for varied floor plans that included front living rooms instead of the standard front bedroom and bath area. Yoder holds the patents on hurricane safety straps for slide-outs and on the "No A frame" design for travel trailers. In 1999, Yoder retired, and Carriage was sold to Arizona investment banker Glen Cushman, who ran the company

The Callista Cove motor home. This Carriage type-C motor home is an example of modern coaches of the 1990s. *Courtesy of the RV/MH Hall of Fame.*

with few changes until problems related to the economic crash of 2008 caused foreclosure and closing in 2009.

In 1968, Edwardsburg, Michigan resident Dan George formed the Georgie Boy RV Company, originally planning to build a full line of recreational vehicles. Georgie Boy shortly evolved into primarily a maker of type-A motor homes, dropping travel trailers and fifth-wheel trailers from its line and creating Damon Corporation as a side company to produce its type-C coaches and a line of very small micro mini motor homes. Damon was eventually closed out, to be resurrected as an independent corporation, and Georgie Boy was purchased and became a subsidiary of Coachmen.

California-based Aristocrat Trailer Company built a branch plant in Elkhart around 1969 to better serve its customers in the eastern half of the country. Aristocrat was, at the time, the country's largest maker of travel trailers. Its forte was smaller, shorter trailers that could be stored in a conventional residential garage, either with its Lowliner model that was less than seven feet high and could be placed directly through a seven-foot standard garage door or through other models that came with very small exchangeable secondary metal wheels that were not roadworthy but could be exchanged with the highway wheels and rubber tires to lower the profile and allow the trailer to clear the residential garage door.

The decade of the 1970s was extremely critical to the RV industry overall, and the Indiana-based companies were no exception. In 1973, the OPEC nations imposed an embargo cutting off sales of crude oil to the United States. This was in retaliation for the United States supporting Israel in the Arab-Israeli war. The effects of the cutoff of oil shipments were almost immediate. Gasoline shortages caused stations to run out of fuel, creating rationing of fuel supplies. Drivers were limited to buying fuel only on odd or even days depending on their license plate numbers. The shortage of fuel caused an almost complete cessation of RV production and sales, especially of motor homes. When drivers could not get fuel for their personal autos, they surely were not inclined to purchase and use an RV that would demand more fuel. The rule of supply and demand caused fuel prices to double and then to quadruple in just a few short months. Smaller and financially weaker RV companies began to go out of business quickly. By the time the Nixon administration negotiated an end to the embargo in March 1974, many Indiana RV manufacturers had left the market, as had companies across the country. Another effect of the oil shortages was the imposition of the fifty-five-miles-per-hour national speed limit as a fuel economy measure more than a safety measure.

In 1979, a second fuel crisis again caused widespread shortages in fuel. Effects in oil supplies related to the Iranian Revolution began to cause panic among fuel consumers fearing a return to the shortages and rationing of the 1973–74 embargo. When the Iraq-Iran war broke out in 1980, oil prices rose dramatically. This crisis had further negative affect on many RV companies that had not completely recovered from the disastrous 1973–74 years, and many more RV producers went under. The recession created by the large jump of over 200 percent in gas prices lasted until the mid-1980s before the RV industry was able to begin to recover. The two crises did not totally stop the RV industry, but most companies were severely downsized, and dozens disappeared from the industry. On the other hand, many new companies came into being during the period.

In 1970, Perry Yoder formed Maple Leaf Incorporated, making the popular smaller-sized travel trailers in Middlebury. Yoder was a creative and forward-thinking engineer, and in 1976, he designed and introduced the first power slide-outs on travel trailers. Up to this time, a few trailers featured "tip outs"—small room additions that were hinged at the floor and folded in to lie on the central floor when in travel mode. In spite of the fact that Perry Yoder's Maple Leaf trailers were quite popular, his undercapitalized personally held Maple Leaf Inc. was unable to survive the second economic crisis of the late '70s and closed down and ceased to exist in 1979, but not without changing the face of the RV industry with a demand for slide-out room additions that continues today. Yoder's career in the RV world, however, was just getting started. In the 1980s, recognizing Perry's strength of leadership, C.T. Yoder recruited him to become CEO of the growing Carriage RV Company. In that position, he became active in industry association work and became the president of the joint Indiana Manufactured Housing and Recreational Vehicle Association. He also co-chaired the association's giant Midwest Mobile Home and RV show that was held for many years at Notre Dame University in South Bend. When Carriage was sold to outside investors, Yoder left his CEO position and became president of L&W engineering, a component design and fabrication subsidiary of Jayco.

Daryl Zook started K-Z Recreational Vehicles in an abandoned gas station in Shipshewana in 1972 to begin building slide-in truck campers. With his attention to quality being noted, his company grew, and he began building a line of travel trailers that he called Sportsmen. Over the years, K-Z grew from its gas station beginnings to occupy nearly 400,000 square feet of production space at its Shipshewana facility, where it builds a wide range

A 1974 Maple Leaf travel trailer. This was the first trailer to feature a power slide-out room addition. *Courtesy of Seth Pingel.*

of travel trailers, fifth-wheel trailers and toy haulers under the Sportsmen, Spree, Venom and Durango brand names. In 2014, K-Z became part of Thor Industries.

In 1976, Bobby Higgins of Elkhart and his Higgins-Delta Corporation received a trademark to begin manufacturing several models of Delta brand type-C motor homes. The company started quickly but did not survive the effects of the second fuel crisis.

CHAPTER 5
The "RV University" Develops

As the RV industry began to recover in the 1980s from the disaster that was the two fuel and economic crises of the 1970s, the pattern of company creation began to change quite dramatically. Most of the companies that we know today have been started not by daring entrepreneurs with personal dreams but by industry veterans who had served an "executive apprenticeship" with the earlier manufacturers. In today's world, very rarely does a new name appear in a leadership position with a start-up RV company. The hundreds of companies with successful records of making all kinds of recreational vehicles have provided an "RV University" where hundreds of executives have gained invaluable training in how to create and grow an RV company. Investors have recognized this available pool of leaders and are building companies with strong, experienced leadership.

Financier and investor Bill Warrick purchased the failing Mallard Coach company in 1979 and moved it from its historic base in Wisconsin to a new home in Nappanee. There, he recruited industry veteran manager Don Pletcher to rebuild Mallard completely from the ground up. Pletcher had an extensive background of successful experience in RV company management. His family had owned the small Fleetwing Traveler trailer company that had been acquired by Coachmen, and he had also worked for and gained a reputation for success at Coachmen, so when Warrick wanted winning experience to rebuild Mallard, he chose Don Pletcher. Pletcher and his team were highly successful in developing the new revitalized Mallard Coach into a well-respected

The Real Lite RV. This is an example of 1980s travel trailer design. *Courtesy of the RV/MH Hall of Fame.*

builder of high-quality RVs. The company gained a respectable market share on a national basis. The Mallard world ended for Pletcher when Warrick received "an offer he couldn't refuse" and sold the company in December 1986 to an East Coast investment banking group that was looking for profit and cared very little for customers and quality. Pletcher stayed with Mallard until the end of the fiscal year and then resigned as CEO. Without Pletcher and his leadership team, Mallard Coach failed and went out of business in less than a year. The Mallard Coach name was later acquired by California-based Fleetwood Enterprises and resurrected as a brand of entry-level trailers.

Pletcher planned to take some time to determine his next direction, but fate intervened. Dan George, who owned the large Georgie Boy manufacturer, had decided to divest or close down his Damon Coach subsidiary, which built his type-C motor homes, especially a line of very small "micro-minnie" RVs. Having worked with type-C and micro-minnies with Coachmen, Don purchased Damon from Georgie Boy and set out to build a team and rebuild it as an independent company. He

determined to drop the micro-minnie portion of the product line, as well as some small towable trailers, and concentrate originally on building type-C motor homes. Damon later added type-A motor homes to its lineup and grew into a major player in the motorized RV world. In the 1990s, Tim Howard, who had come to Damon from Mallard with Pletcher, convinced Don that a line of park model RVs would be a good addition and was placed in charge of directing the development of Damon's Breckenridge Park Model operation in Nappanee. Breckenridge became a popular choice of park model trailers, which are designed not to be repeatedly towed on the highway but to be placed permanently or semi-permanently in an RV park or campground. Also in the '90s, Pletcher purchased the small Camplite line of folding camp trailers, adding yet another member to the Damon lineup and establishing it as a full-line RV builder. In 2003, Damon Corporation became part of industry giant Thor Industries.

A 2003 Gulfstream Friendship. This is an example of the fine coaches made by Gulfstream in the years before the 2007–08 economic crisis. *Courtesy of Al Hesselbart.*

In 1983, the Shea family of Nappanee, who had started the Fairmont Homes company building manufactured homes in 1971, entered the RV industry with the creation of a sister company called Gulfstream Coach. Under the leadership of Jim Shea Sr., Gulfstream grew to become a well-respected successful full-line RV manufacturer building a full mixture of travel trailers, fifth-wheel trailers and all sizes of motor homes, from van campers and type-C coaches to full-sized type-A diesel pushers. In 1990, Gulfstream Coach was assigned to the second generation, Jim Jr., Dan and Brian Shea, while Jim Sr. kept his attention on the housing company. During the economic crisis of 2009–10, Gulfstream Coach discontinued its production of motorized RVs but continued production of high-quality towable RVs. Motorized brand names were resurrected in 2015.

Four Winds International was created in 1990 as a sister company to Dutchman Manufacturing. Dutchman built towable RVs, and Four Winds was created to build class-A and class-C motorized rigs. Four Winds products quickly proved to be popular with the RV consumers, and the company was purchased into the growing Thor Industries after only two years of development in 1992.

In 1985, Pete Liegl, who had been a sales manager with Coachmen and president of Coachmen subsidiary Shasta before being dismissed, acquired a small RV company and van converter named Van American with two partners and, by starting the Cobra RV company, created Van American–Cobra in Elkhart. Along with his partners, Dale Glon and Juergen Boessler, who also came with Coachmen experience, he built what became Cobra Industries into a national giant with multiple brand names. Later, they purchased Rockwood, a Goshen-based manufacturer of mini-motor homes, travel trailers and folding tent campers that had been founded by Arthur Chapman in 1972. Chapman had received his industry orientation working for his grandfather's company, originally called Star Tank and Boat and later known as Starcraft. At the time, Rockwood was part of the holdings of investment company Lear Siegler but was being sold off as part of a reduction in Lear Siegler's assets. Cobra, including Rockwood, grew quickly and in 1992 was sold to a New York–based group of private investors who took the company public but kept Liegl on as chief executive. At this time, Cobra Industries was the fifth-largest RV manufacturer in the nation, and Liegl, Glon and Boessler each made a great deal of money in the cash sale. With Liegl running the show but constantly being second-guessed by the investors, Cobra began to go downhill, and he was again released from his company presidency. By 1995, without Liegl's leadership, Cobra was in bankruptcy.

In 1996, Liegl repurchased certain assets of the defunct Cobra Industries from the bankruptcy proceedings, including many of the factories and all of the brand names but not the Cobra name or any of Cobra's liabilities. These assets became the foundation for his new company, Forest River. Liegl again performed his magic, and Forest River, including the Cobra and Rockwood brand names, grew to be an industry giant. In 2002, he purchased Vanguard Industries, maker of Palomino brand RVs. In 2005, the dynamic company caught the eye of Warren Buffett, head of the huge Berkshire Hathaway combine, who reportedly paid in excess of $1 billion for 100 percent of Forest River stock, again keeping Pete Liegl as CEO but pledging to stay out of the management decisions. In 2008, Buffett also purchased the outstanding stock of industry giant Coachmen Industries, combining it with Forest River and creating one of the largest RV manufacturers in the country. In 2010, Forest River reintroduced the historic Shasta brand name that, while owned by its Coachmen partner, had laid dormant for several years. In 2009, Liegl created Prime Time Manufacturing in Wakarusa and selected Forest River veteran executive Jeff Rank as its president. Prime Time created several popular lines of towable RVs, both travel trailer and fifth-wheel models, including the Crusader line of lighter weight fifth-wheel trailers that made trailers from twenty-five to twenty-nine feet in length that were designed to be pulled by the common half-ton pickup trucks and did not require the heavier and rougher-riding three-quarter- and full one-ton trucks. By 2011, Prime Time was being recognized as the fastest-growing RV manufacturer in America.

Pete Liegl. Having served as an executive in several RV companies, he is the founder and CEO of Forest River. *Courtesy of the RV/MH Hall of Fame.*

In 2011, Forest River bought specialty RV maker Dynamax, becoming arguably the largest RV manufacturer in the world. Dynamax had been created in 1997 by RV and van conversion industry veteran Richard Strefling to build primarily custom-made high-line luxury type-C coaches that were sold under the Isata brand name not as motor homes but as "luxury touring vehicles." Dynamax has added a DynaQuest line built on large Freightliner semi-truck chassis and a line of high-luxury fifth-wheel trailers using the Trilogy brand name. Some of its large coaches have been built as mobile command center vehicles for police and other first responder departments for use in disasters and other emergency situations.

In addition to its RV products, Forest River is one of the world's largest builders of shuttle and transit buses through subsidiaries that include General Coach in Canada, Goshen Coach, Elkhart Coach, Glaval Bus and Starcraft Bus and Mobility, a line of specialty handicap and wheelchair-accessible transports. It also manufactures cargo trailers under the Rockport, Cargo Mate, Continental Cargo and U.S. Cargo brand names and several brands of large and small pontoon boats through a Forest River Marine division.

In 1984, Bison Coach was created in Milford as a builder of specialty trailers, primarily equine or horse trailers. In 2003, Bison became a true member of the RV world when it began to add luxury RV-style living quarters to its horse trailers. Bison Coach was acquired by Thor Industries in 2013.

In 1989, Glen Troyer, a former executive with Nappanee-based luxury RV manufacturer Newmar Corporation, started Travel Supreme Corporation in Wakarusa to specialize in luxury fifth-wheel trailers designed and built for the growing popularity of full-time RV living. His products quickly received rave reviews, and the company grew to employ hundreds of workers as a major business in the small town, which was also home to the large Holiday Rambler Corporation. In 1999, Travel Supreme introduced a similar line of high-priced luxury motor homes that carried the same popular features as its towable products. By this point, Travel Supreme had built a national network of over two hundred dealers distributing its coaches. Eight years later, as the economic crisis of 2008 approached, Troyer's company fell on hard times and closed all its operations in January 2008. The assets of Travel Supreme were acquired through the bankruptcy proceedings by Jayco, which established a new division and continued many of the Travel Supreme diesel pusher motor coach designs as the Entegra Coach division of Jayco.

In 2003, Brian Brady, who had been president of Damon under Don Pletcher and had left in 2001, joined with Scott Tuttle and gathered a team

of industry veterans to start the Heartland RV Company in Elkhart to build top-quality fifth-wheel trailers. Heartland deviated from the normal product development pattern when its first introduction was what was to be its top-of-the-line flagship model, the Landmark, instead of beginning with the basics and working its way up to the luxury models. Heartland entered the RV industry with nearly unprecedented explosive growth in the fifth-wheel market. It showed over 200 percent annual growth for each of its first several years in the marketplace with its upper-class line of trailers. In early 2010, Heartland purchased the brand name rights to all the towable RV assets of the bankrupt Fleetwood Enterprises to market travel trailers in addition to its fifth-wheel units, and a few months later in 2010, it became a part of Thor Industries. Tuttle left Heartland and went to Wakarusa, where he started Livin' Lite, building unique small trailers. He sold Livin' Lite to Thor nearly as soon as it got under operation.

In 1987, Fleetwood Enterprises, the giant California-based RV and mobile home manufacturer, had built a completely new RV manufacturing complex in Decatur, Indiana, to build its new line of diesel pusher motor homes. In 1989, the new Fleetwood Limited luxury diesel coaches were introduced to the American public. In 1991, the Indiana-based division was renamed American Coach, and a whole line of luxury, permanent living–style motor coaches was introduced. With this change, the Fleetwood Limited name was changed to American Eagle. In 1994, the American Dream was added as a premium alternative to the American Eagle. In 1995, American Coach introduced its motor homes with the new wide-body concept, increasing the width from 96 inches (8 feet) to 102 inches, as allowed by federal highway regulations, making the coaches more spacious. In 1999, American Coach garnered the attention of the motor sports industry, and many racing teams begin using its products as travel support vehicles. In 2007, American Coach introduced the availability of full wall slide-outs on its coaches, adding more space to their livability. In 2009, badly damaged by the economic recession of 2008 and several internal problems, Fleetwood Enterprises was declared bankrupt, and its various divisions were broken up and sold to different corporations. All the motor home brands, including the Decatur manufacturing complex and the Fleetwood name in their purchase, were sold to a holding company identified as Allied Specialty Vehicles. Creating the new name of Fleetwood Recreational Vehicles, it continues to build American Coach models, as well as the other Fleetwood brands of Southwind, Bounder and Pace Arrow and the newly acquired Monaco and Holiday Rambler coaches, at the Decatur facility.

In 1989, when the Aristocrat trailer company was failing—in part because its products had not kept up with the new standards of larger size and greater luxury in RVs—Elkhart investor Dave Hoefer negotiated to purchase the Elkhart assets of the California-based Aristocrat. As he took over the company, he changed the name to Dutchman Manufacturing and designed a complete new line of products. He hired ex-Coachman executive Coleman Davis to build his new company based on Davis's reputation for integrity and aggressiveness. Under Davis's leadership, Dutchman quickly grew to become a major national player in the manufacture of towable RVs. In 1991, Dutchman became the first Elkhart acquisition of Thor Industries. Cole Davis eventually left Dutchman and in 1996 started his own company that he called Keystone Recreation Vehicles. Following Davis's stated goal of building a quality trailer priced much lower than the competition, that company exploded onto the RV scene and by 1998 had exceeded $100 million in sales. By 2000, Keystone was the largest builder of fifth-wheel RVs in the country. Keystone's success was based in great part on the outstanding team of veteran RV company executives Davis was able to put together. He recruited vice-president-level personnel from Four Winds, Coachmen, Elkhart Traveler and others and gave them each the freedom and responsibility to do their individual jobs. In its first five years of existence, following Davis's unique business plan, Keystone exhibited a phenomenal growth rate of over 17,000 percent. Keystone was sold to Thor Industries in 2001.

In 1990, David Fought, who had been an executive with Starcraft RV, joined with Elvie Fry to form the Sunnybrook RV company and begin building a full line of towable RVs. In the mid-1990s, Sunnybrook acquired the name and assets of the failing Shadow Cruiser RV company that had in the '70s and '80s been a builder of slide-in pickup truck campers, including a popular line of pop-up slide-in campers where the roof folded down to reduce height for travel. Shadow Cruiser had added a line of fifth-wheel trailers to its lineup in the 1990s, which may have added to its financial problems. In 1999, the Pat Makusky family purchased the Shadow Cruiser name from Sunnybrook and started Cruiser RV, dropping the word "Shadow" from the name. In 2000, they began to build some smaller seven-foot-wide fifth-wheel trailers using designs that had been introduced earlier by Shadow Cruiser. In 2004, Cruiser RV moved from the Shadow Cruiser location in Bristol to a larger facility in Howe, Indiana, to increase production capability.

In 2002, Sunnybrook Manufacturing, the parent company of Sunnybrook RV, formed a luxury fifth-wheel company it called Doubletree RV to build

large full-time RVs under the Mobile Suites brand name. David Fought took over the management of Doubletree and eventually bought the division, growing it as an independent company. Along the line, the Doubletree hotel chain challenged the use of the Doubletree name, and Fought dropped the Doubletree name, continuing in business using the simple DRV letters-only identity. Fought then acquired the Cruiser RV Company, completing a circle in bringing the remnants of Shadow Cruiser back into his fold, having first had them as part of Sunnybrook's acquisition in the '90s. DRV and Cruiser RV have both grown into major players in the modern RV world, and both were purchased by industry giant Thor Industries in 2015. Dave's son Jeff Fought was made president of Cruiser RV in 2015. In 2010, Iowa-based RV industry giant Winnebago Industries purchased Sunnybrook as a way to return to offering a line of towable RVs that had been gone from its line since the early 1970s without having to establish recognition of new brand names. Today, the Sunnybrook name is being replaced by Winnebago as the parent of all of its towable products.

In 2002, Bob Helvie, owner of Startracks Custom Vehicles of Elkhart, acquired the rights to the Xplorer motor home that had been made in Michigan since 1967 and began to produce a variety of van campers and class-C motor homes under the Xplorer brand, in addition to the handicap-accessibility products he was also making.

Also in 2002, Dave Hoefer, an industry veteran who had been involved in the start of both Dutchman and Four Winds successful companies, gathered a team of experienced industry veterans and started Pilgrim International in Elkhart to build a new line of RVs using the very latest materials and technologies. In 2007, Pilgrim introduced a line of eco-friendly trailers made using 100 percent composite materials and no wood in their construction. Pilgrim quickly grew to be recognized as the fifteenth-largest builder of towable RVs in the country, but its timing was all wrong. With the worries over the economic crisis of 2008 and in spite of having over $9 million in orders and $4 million in receivables, its bank lost confidence in the entire RV industry and shut the company down in September 2008.

In 2004, industry veteran Peter Recchio and several other experienced RV company managers, most of whom had earlier worked together at Carriage, started Ameri-Camp RV Company in Syracuse and began to build some innovative travel trailers and fifth-wheels. As they slowly began to develop their unique products and recruit an experienced production team, they received several industry awards. Their Summit Ridge models were factory designed and built as handicap-accessible products. Unfortunately,

their slow and studied business plan, which had received praise from many industry leaders and organizations, had not stabilized their financial security when the crisis of 2008 hit. Ameri-Camp did not have the financial strength to survive the recession, and the company was disbanded in 2009.

In 2007, Randy Graber of Shipshewana started the Open Range RV Company with only three employees. His target was to build a line of affordable, lightweight travel trailers and fifth-wheel trailers with some innovative features and unique floor plans. Graber's plan succeeded, and his company grew over 30 percent each year through 2012, which was remarkable considering that the recession years from 2008 to 2010 were one of the most serious downturns in recreational vehicle history. The Open Range sales motto for its customers of "Enjoy the Journey" could also very well apply to the company employees. Open Range's amazing growth brought it to the number five position among all fifth-wheel trailer builders in 2012. Open Range joined with newly formed Highland Ridge RV to become part of industry giant Jayco in 2014.

Open Range was not the only Indiana RV company to buck the industry trend during the economic crisis of 2008–10. In 2008, industry veteran Kelly Rose and a team of highly experienced RV executives took a chance and started a unique line of ecologically friendly RVs with a company called Evergreen to build its trailers with all composite materials without the use of wood. They originally built their company around designs and concepts created by the failed Pilgrim RV Company. The Middlebury-based company grew rapidly, as the unique designs and considerably lighter weight of its all-composite trailers provided better fuel mileage for the towing vehicle. Evergreen not only quickly received acceptance in the United States but soon began exporting trailers to Australia as well. After the historic Carriage RV company failed in 2009, Evergreen acquired many of its luxury fifth-wheel designs and recruited much of Carriage's workforce to, in 2012, start the new Lifestyle RV company as a subsidiary to build a complete line of luxury full-time living fifth-wheel trailers in an attempt to fill the void left by the loss of Carriage. In 2015, Evergreen purchased the RV brands and designs of the sixty-five-year-old Skyline Corporation and moved its production from Elkhart to the Middlebury campus. In June 2016, Evergreen came into sudden financial distress and closed its doors, releasing over three hundred skilled RV builders, most of whom were quickly hired by other local builders.

Another company to attempt to create ecologically friendly RVs during the economic crisis period was started in Elkhart but was, in 2010, recruited

A 2015 Nexus Phantom. This shows the type of motor homes built by one of the industry's newest companies. *Courtesy of Al Hesselbart.*

to move to Marion with much financial support from that community. Organized and started by veterans of the closed-down Pilgrim International, Earthbound RV built its trailers entirely without the use of wood with a combination of welded aluminum and aircraft-type composites. Earthbound did not succeed in Marion and went out of business in 2013.

In 2010, industry veterans Claude Donati and Dave Middleton opened a totally new RV company with a unique marketing plan. Nexus RV was created with a factory-direct sales plan, where company leadership would interface directly with each individual customer without any dealer sales force in between. It opened with three upper-class large type-C motor homes: the Viper, the Phantom and the Ghost. By recruiting past Gulfstream Coach motorized division president Brian Shea as a primary investor, it was able to double its sales in each of its first four years. In 2015, Nexus introduced a high-line diesel pusher class-A coach, the Bentley, to popular acceptance.

Industry giant Thor Industries was begun in 1980 when wealthy investors Wade F.B. Thompson, an immigrant from New Zealand, and Peter Busch Orthwein, whose great-great-grandfather Adolphus Busch founded the Anheuser-Busch brewing conglomerate, acquired Airstream,

the oldest active name in RVs and combined the first two letters in each of their last names to form Thor as their management company. At the time, Airstream was owned by Beatrice Foods but did not fit well into its product mix and was failing under the effects of the crisis of the '70s. Airstream returned to profitability in its first year under Thor management. Through the 1980s, Thor acquired several small Canadian and American recreational vehicle and bus companies, becoming the world's largest builder of small- and medium-sized buses. It began its concentration on northern Indiana–based RV companies in 1991 when it purchased Dutchman Manufacturing, a maker of

Above: Wade F.B. Thompson. A naturalized American, New Zealand native and one of the co-founders of Thor Industries, he was the key voice in the development of the nation's largest RV manufacturer. *Courtesy of the RV/MH Hall of Fame.*

Left: Peter Orthwein is the co-founder and current board chairman of Thor Industries. *Courtesy of the RV/MH Hall of Fame.*

a full range of towable RVs. Thor established a practice of purchasing successful, profitable companies and maintaining the existing leadership to continue what made them work. In 1992, it acquired Four Winds International, a builder of motorized products, and in 1995, Skamper, a builder of campers came into its stable.

Over the next twenty years, Thor Industries moved to solidify its position as one of the two largest recreational vehicle manufacturers in the world alongside Elkhart-based Forest River Corporation. It acquired Keystone, a major builder of fifth-wheel trailers, in 2001, followed quickly by the purchase of Damon Corporation, a maker of type-A motor homes, in 2003. Topeka-based Crossroads, a builder of fifth-wheel trailers, came aboard in 2004. In 2010, Thor acquired Heartland Corporation, a major builder of luxury fifth-wheel trailers that had just purchased all of the towable brand names of the bankrupt industry giant Fleetwood Industries from the bank receiver. Heartland then moved into producing its first line of conventional travel trailers using the iconic Fleetwood brand names, such as Prowler.

In 2013, with well over half of its holdings in the Greater Elkhart and South Bend area, Thor decided to move its corporate headquarters from its longtime home at the Airstream complex in Ohio to the previous Coachmen Industries corporate headquarters building now vacant in the city of Elkhart. It continued its dynamic growth with the acquisition of Wakarusa-based small lightweight trailer builder Livin' Lite in 2013, along with Milford-based combination horse trailer–luxury RV builder Bison Coach. The growth continued with the purchase of Shipshewana towable RV builder K-Z RV in 2014. Thor acquired Howe-based towable manufacturer Cruiser RV and all of its subsidiaries in 2015, along with another Howe-based luxury fifth-wheel trailer maker, DRV.

In 2011, three presidents of different Thor Industries divisions left their positions to investigate the possibility of creating a joint venture. Brothers Ron and Bill Fenech and Don Clark all had over twenty-five years of experience in executive positions in the RV world. After having begun with various other manufacturers, they became a part of the team that worked with Cole Davis to build Keystone RV Company into the major player that it became. When Keystone became part of Thor, each of the friends became a president of a different Thor division. Clark was president of Dutchman Manufacturing, Bill Fenech was president of Thor Motor Coach and Ron Fenech was the head of the overall Thor RV division. As partners, they conceived a new RV company dedicated to high-quality fifth-wheel trailers and set about hand-selecting and recruiting a team to

begin building three different models of trailers in a company identified as Grand Design Recreational Vehicles. They found an available production facility in Middlebury with over 400,000 square feet of factory space on a sixty-acre campus that they were able to acquire with available cash so they could start Grand Design debt free. They individually selected and recruited team leaders for each of their production departments, and in January 2013, Grand Design went into production with seventy employees. Its products and designs proved to be very popular, and by 2015, over five hundred employees were sending out hundreds of high-quality Solitude, Reflection and Momentum fifth-wheel brand trailers to dealers and customers from coast to coast. In early 2016, Grand Design celebrated the delivery of its 20,000th luxury fifth-wheel trailer and began construction of a large additional production facility in Middlebury.

Conventional RVs are not the only recreational vehicles made in Indiana. In 1974, as cruising-style larger motorcycles began to grow in popularity, Keith Snelson, a manager with an RV company being pressured by the nation's economic crisis, was dreaming of a source for new RV customers. When his job ended, while not a motorcyclist himself, Snelson recognized bikers' love for the outdoors. A company called Time Out Trailers was born in Elkhart to design and build camping trailers that could efficiently and legally be towed behind these larger motorcycles. In early 1975, he took a few of his original very basic campers to a motorcycle show in Cincinnati, Ohio, and was amazed when cycle dealers wanted to order his campers for stock. The first trailers were nothing more than tents to be unfolded and set up on flat platforms, but they evolved to set up into a bedroom that could comfortably sleep up to four persons. Time Out developed a variety of trailer styles that could provide very comfortable temporary living quarters when fully opened up on a campsite. It has since added a number of specialty and cargo trailers, all designed to be pulled by two- or three-wheeled vehicles. Time Out Trailers continues after over forty years in its single Elkhart facility to produce many sizes and styles of both camping and cargo trailers to be towed behind motorcycles and some of today's smallest cars.

In 2008, another trailer company was born in Elkhart to resurrect a style of trailer that had been popular in the 1940s and '50s. Tom Pontius created the Little Trailer Company to design and build an updated version of the teardrop trailers of the immediate post–World War II years with a model called Little Guy. Teardrop trailers are usually no more than a maximum of four feet tall and built in a teardrop shape, with little more than a mattress

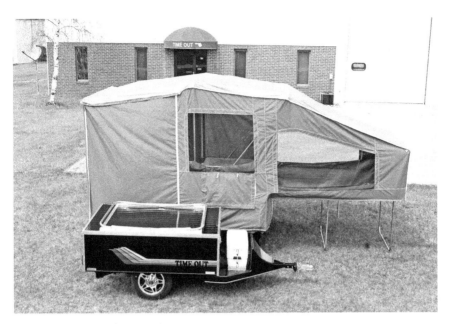

The 2016 Time Out Trailer. Time Out trailers are uniquely designed to be pulled behind modern cruising motorcycles. *Courtesy of Time Out Trailers.*

bed inside the body and the kitchen and other amenities inside a hatch at the tail end. A true teardrop has no stand-up room, and the living space, other than lay-down room, is provided by the great outdoors. One advantage is that they can be towed by the smallest four-cylinder economy cars. Little Guy trailers are now marketed by an Ohio-based company but were born and developed in Elkhart.

In 1997, specialty RV company Kibbi was created in Bristol by industry veteran Chuck McKibbin to build Renegade brand motor homes. Renegade was created to build custom heavy-duty coaches and combination coach-trailer rigs primarily for the auto racing industry. The company has expanded to build some other specialty vehicles but remains a low-volume custom heavy-duty RV manufacturer.

In 2012, the Eterniti Caravan Company was started in Goshen specifically to make luxury travel trailers for export to the English caravan market. Eterniti was one of the first to offer power slide-outs, power awnings and air conditioning to the British market. After receiving rave reviews from the English RV press, Eterniti, which was built in America on a German-made frame and chassis, failed to gain acceptance and was withdrawn from the market in March 2014.

In 2013, RV industry veteran Charles Hoefer created Global Caravan Technologies (GCT), based in the Indianapolis suburb of Speedway, home of the world-famous racetrack. GCT has the goal of using carbon fiber technology to build an ultra lightweight, luxurious large travel trailer equal to the finest motor homes for the worldwide market. Using aircraft and race car aerodynamic principles, Hoefer has described his design concept as "slippery." In 2014, Hoefer, in an internal squabble, was voted out as chairman and CEO, and Harrison Ding became CEO. Among the investor partners in GCT is the Dallara race car firm. The CR-1 original thirty-five-foot luxury carbon fiber trailer features double slide-outs, leather ceilings and walls and carbon fiber cabinetry.

The RV industry—not only in Indiana but nationally—has changed dramatically since the turn of the twenty-first century. From the troubled years of the 1970s through the 1990s, three major companies were looked upon as the largest in the industry: Fleetwood Enterprises of California, Winnebago Industries of Iowa and Indiana's Coachmen Industries from Elkhart. But they did not totally dominate the RV landscape. Since about the year 2000 and especially since the economic recession of 2008 and 2009 and the fall from grace of both Fleetwood Enterprises, which went bankrupt and was split up and sold off to various owners, and Coachmen Industries, which was acquired by another, two Elkhart, Indiana–based companies have come to amazing domination of the RV world. Publicly held giant Thor Industries and Forest River, held by financial giant Warren Buffett's Berkshire Hathaway, have through dynamic growth and by acquisition gained over 60 percent market share in the RV industry between the two. Both companies, now based in Elkhart, hold over a dozen subsidiaries and manufacture possibly nearly one hundred different RV models. These two corporations vie very actively for the position of the largest builder, and in truth, the size and production number difference is negligible between the two. With the addition of Jayco, which is the largest privately held RV company, and the many other RV manufacturers in the area, the Elkhart–South Bend area of northern Indiana continues to qualify not only for the title of RV Capital of the World, as it has since the 1940s, but also as home to nearly 85 percent of the RVs made in the entire United States.

CHAPTER 6

The Component Manufacturers

I t is important to note that the modern RV industry differs from many
other industries in that the company whose brand name appears on the
final product, in most cases, has built very few of its components. A modern
recreational vehicle is primarily a box designed either to be driven or towed
behind another vehicle that has been set or built on a skeletal frame often
designed and built by someone else that, in turn, is set on a suspension and
set of axles also built by someone else. The interior is also a collection of
parts made by many others. From the floor covering, either tile or carpet,
to the wall paneling, cabinetry, furniture and appliances, most of the RV
manufacturers rely on specialists to provide every part of their end product
except the shell. To a degree in the 1930s, but especially in the 1950s, the
component manufacturers from all around the country determined that it
was important for them to have a presence in the South Bend–Elkhart area
of northern Indiana. Many suppliers developed huge warehouses where
they could maintain an inventory of materials to supply the demand from
the RV builders. Others built satellite factories where they could produce
the items needed for RVs. In addition, many local entrepreneurs started
companies to provide products that in many cases they had invented to fill a
perceived need in the manufacture and assembly of RVs. In some cases, RV
companies themselves started subsidiaries or totally separate companies to
build component parts for themselves and for others.

In 1938, the Elkhart Welding and Boiler Works joined the growing list
of companies providing components needed by the trailer builders when

it began making custom-designed undercarriage frames for the industry. Later, the company was acquired by August Bock and, as Bock Frames, became one of the largest trailer frame manufacturers in the world. In 1940, Elkhart's Barnes Heater Company joined the supplier list when it began to design and build smaller furnaces for the trailer makers.

In 1941, Elkhartan Ralph Morgan, a Schult salesman, successfully lobbied the Interstate Commerce Commission for the right to develop the first commercial carrier to deliver RVs made by other companies to dealers throughout the nation. Morgan Drive Away grew as a delivery service that started with Morgan pulling trailers with his personal car, through the '40s, '50s and '60s to having over three thousand drivers in a combination of private contractors and company employees delivering both RVs and mobile homes to dealers and parks throughout the United States and Canada.

Above: August Bock designed and engineered a wide variety of frames for RV and mobile home manufacturers. *Courtesy of the RV/MH Hall of Fame.*

Left: Ralph Morgan. As the founder of Morgan Drive Away, he was the key pioneer in the transportation of RVs from the manufacturer to the dealer. *Courtesy of the RV/MH Hall of Fame.*

Among Morgan's many contributions to the RV transport industry is the design for the long, sloped-deck "beaver tail" trailers that can carry many smaller RVs for dealer delivery and are easily unloaded, with the roll off facilitated by the continuously sloped deck.

Terrell J. Reese started building trailer-stabilizing jacks and pulling hitches in Elkhart in 1952. A very innovative engineer, Reese dove into the burgeoning trailer industry and developed a wide range of towing and leveling devices for the trailer operator. Among his creations was a line of aluminum jack stands to securely support a trailer when it was set up for use that continues to be available today. Reese equalizing hitch systems allowed larger trailers to be towed by automobiles without affecting the handling and safe drivability of the car. By the late 1960s, Reese was so respected for his dedication to quality towing equipment that he was asked by the national industry to develop a set of tests regarding safe towing loads that resulted in the certification of the SAE J684 federal standards for safe towing. Among his revolutionary and lasting developments making today's RV lifestyle safer and easier for all drivers are custom-designed bolt-on receiver hitches, removable fifth-wheel hitches, sliding fifth-wheel hitches, class-IV trailer hitches and multi-fit trailer hitches. Over fifty years later, most of Terrell Reese's many contributions continue to be looked on as industry standards. The Reese Hitch company has today become a part of the giant Cequent Products Group, an international combine holding over fifteen different trailer accessory manufacturers.

In the late 1950s, Russian immigrant Leon Shahnasarian, who had received an engineering education in Latvia

Terrell Reese. Reese's creation of easy-to-use stabilizing jacks and trailer hitches modernized the trailer industry in the 1950s. *Courtesy of the RV/MH Hall of Fame.*

prior to coming to America, began to distribute various components to the growing trailer industry through a company he called Instamatic Corporation. Knowing that the early compressor-style refrigerators used in trailers were inefficient and undependable, Leon went to Sweden in 1957 to negotiate with the huge Electrolux Corporation for the right to distribute its brand of Dometic gas/electric absorption refrigerators to the trailer industry in America. He was able to receive a ten-year contract as the exclusive distributor to the trailer market throughout the United States for a product that no American manufacturers were yet using. Establishing a warehouse in Elkhart to stock the Swedish-built refrigerators in what had become the national center of trailer production, Shahnasarian set out to sell trailer manufacturers on the advantages of his imported line of refrigerators over those commonly in use. Added to the fact that his refrigerators were superior to those available at the time, Leon established a program of training and support for the manufacturer and dealer technicians who would be installing and servicing the Dometic products. His growth of market share was so great that at the end of his ten-year contract, Dometic refused to renew its agreement with Instamatic and came to America to establish a corporate presence and begin to distribute its own products. Not to be defeated, Shahnasarian secured lines of air conditioners and space heaters, as well as his own brand of Instamatic gas/electric water heaters, to continue to serve the trailer industry's need for quality appliances. Leon eventually went to Argentina, where he began producing his own brand of absorption refrigerators under the Coldstar brand name for import into the United States. Coldstar refrigerators were sold for a few years but eventually went out of business. His program of training for technicians and other installers dealing with his products has become an industry standard. The introduction of the absorption technology in a combination gas and electric refrigerator was a major contribution to the popularity of today's RV lifestyle. The ability of RV manufacturers to replace iceboxes and camp coolers, as well as the inefficient and undependable early compressor-style refrigerators, made RV travel a much more enjoyable experience for the self-contained traveler of our time.

In 1952, brothers Ermon and Roy Beck acquired steel fabricator Hart Pressed Steel and created the Beck Corporation in Elkhart to build frames for the locally developing RV and mobile home industries. They developed a method for cold cambering their steel forms, a system for dip painting their completed frames still in use today, and invented the removable A frame design used on many park model RVs. They built Beck Corporation

into the largest trailer frame builder in the country in the 1970s and '80s. In the 1990s, Roy also developed Beck Air, an Elkhart-based air charter service that was used by many RV executives to travel from plant location to location as the local RV manufacturers diversified with plants in many locations around the country. The Becks were generous philanthropists who supported many not-for-profit charities throughout the Elkhart–South Bend area.

Mervin Lung, an Elkhart used car dealer and insurance salesman, saw an opportunity and joined the growing list of firms supplying component materials to the burgeoning RV industry in 1959 when he created Patrick Plywoods to provide that essential product to the manufacturers. Patrick grew to become one of the nation's largest suppliers to the RV industry with the addition of pre-finished paneling for trailer interiors to replace the traditional construction with raw woods to be sprayed with varnish or shellac after the trailer was assembled, which was an extremely dangerous practice for the spray operator, who had to work in the fog of shellac or varnish while finishing the interior. Its products grew to include cabinets ready to install and many other needed trailer interior products, and the name was changed to Patrick Industries to reflect the variety of materials being provided. The company's growth expanded to having warehouses in sixteen states to be able to provide locally available service to the national industry. One of Patrick's greatest contributions to the industry, while directed primarily toward the related mobile home segment, was the introduction of gypsum board drywall to replace wood paneling in modern factory-built homes. Drywall construction, which replaced the use of wooden paneling, largely altered the design, decor and acceptance of the housing side of the trailer industry. Drywall has worked its popularity into many of the park model RVs that are rapidly gaining acceptance in the long-term residence RV parks around the country. Today, Patrick Industries, through its more than twenty-five subsidiary companies, can provide nearly any part needed to build an RV.

Also in 1959, lumber giant Georgia Pacific (G-P) Corporation recognized the demand for wood products created by the exploding trailer industry in Elkhart. It acquired the National Plywood Company with a 50,000-square-foot warehouse on Elkhart's south side to be able to have plywood and other wood products available locally for its customers. Demand for its materials grew rapidly, and in 1968, G-P built a new facility of over 100,000 square feet on Elkhart's east side to keep up with demand. Its growth has continued, and today its presence in Elkhart has grown to over 280,000 square feet, including a private rail siding for railroad delivery of its products. In 2004,

the distribution division of Georgia Pacific was purchased by a group of corporate executives and became known as BlueLinx Corporation.

In the early 1960s, Elkhart native Vernon Sailor created a major change in the design and features of all RVs and mobile homes that continues to this day. From the 1930s, any trailer that had a screen door in addition to its security exterior door used a wooden framed door. Sailor invented a much lighter aluminum-framed screen door that could easily be built to fit any sized door opening and started the Sailor Manufacturing Company to supply his screen doors to the many trailer manufacturers in the Elkhart area. The aluminum screen doors were nearly instantly accepted by the trailer industry, and their popularity grew nationally. In the 1980s, Vern Sailor made his presence known in the site-built housing construction industry when he invented and patented a metal door for homes to replace the wooden solid core or hollow core doors that were the industry standard. He followed that creation with a pre-framed combination solid and screen door that could be easily set into a

pre-built opening in either a trailer or residential home. He also developed a pre-framed aluminum window assembly. Vern Sailor became very active with both the Indiana state and the national RV builders' associations and served three terms as the chairman of the national RV Suppliers Show. He became a well-known philanthropist, supporting many youth-serving and educational institutions.

Leonard Dexter of Elkhart created Dexter Axle Company in 1960 to design and build specialty axles for the booming trailer industry. The company grew quickly to provide axle assemblies

Vern Sailor. Sailor's company changed the design and construction of trailer doors, evolving from wood frame to aluminum screen doors. *Courtesy of the RV/MH Hall of Fame.*

not only to the RV factories but also to the related mobile home, cargo and utility trailer, horse and livestock and boat trailer makers. Now managed by the third generation of the Dexter family, Dexter Axle is the world's largest supplier of trailer axle assemblies.

In the mid-1960s, the RV industry was becoming more sophisticated with its products, which were becoming more comfortably appointed and were no longer such rustic campers. Magic Chef Corporation introduced its kitchen ranges to the industry and assigned Fred Haile to sell the industry on its products. For twenty years, Haile toured the country from coast to coast, and Magic Chef became a prime kitchen range in both RVs and mobile homes from a sales center based in Elkhart.

Fred Haile. Known industry-wide as the Magic Chef Man, Haile converted RV kitchens from propane countertop hot plates to full-function gas ranges. *Courtesy of the RV/ MH Hall of Fame.*

Robert Moore Sr. of Elkhart saw an opportunity in the growing RV industry in 1966 and closed down Moore Products, a company that cleaned carpets and sold carpet-cleaning equipment, to create a company he called Mor/ryde to build a rubber spring suspension system that he had invented for trailers. This new suspension system utilizing rubber block springs and torsion bars in lieu of the conventional leaf spring suspension dramatically reduced the tendency of trailers to sway when being pulled. Mor/ryde suspension quickly became a part of many of the higher-quality trailers built in the Elkhart area. The company's product line has grown over the past fifty-plus years to over two thousand different products, most related to the RV industry but serving many other customers as well. Mor/ryde's largest division now modifies vehicle chassis, shortening or lengthening factory motor home chassis as needed by RV manufacturers for the many different RV designs but continues to build the suspension system on which

the company was founded. It also produces cargo bin sliding trays that allow RV consumers to easily access items stored in the compartments deep under their rigs. The company is now run by Moore's sons Bob Jr. and Ronald, occupies three large plants around the city of Elkhart and employs a staff of nearly six hundred team members.

Making note of the rapid expansion of the RV industry and the resulting demand for various wood products, in 1966, Robert Weed established a company in rented space in the building where, in 1936, Schult had started his business to distribute a wide range of laminated wood products. Robert Weed Plywood was created to provide the Elkhart-area RV manufacturers with finished hardwood paneling, decorative vinyl-finished paneling and wood grain paper–coated paneling. In 1969, Robert Weed Plywood moved to its own facility in nearby Bristol, where the company still operates under the second and third generations of the founding family. Weed created a large selection of both true and imitation hardwood veneer sheets, allowing RV designers to create a nearly unlimited variety of interior looks. One of his popular services was providing cut-to-size panels so that the manufacturer could immediately use his products without having to modify them to fit. Demand grew quickly for Weed's products not only from the RV industry but also from the manufactured housing, marine yacht, cabinet, office furniture and funeral casket manufacturers. In 1986, the company created a unique design center with professional designers where company designers could come and, under perfect lighting and conditions, create new patterns for their paneling. It has also pioneered the Azdel panel, a totally composite product using no wood that can be imprinted with wood grain or any decorative image and provide a completely waterproof and vermin-proof basis for RV interiors. By 2000, Robert Weed Plywood was utilizing over 750,000 square feet of production facilities in Bristol, Indiana, and a supplemental operation in Idaho.

In about 1970, several makers of larger motor homes began to experiment with adding diesel power to their coaches. Diesel fuel was, at the time, cheaper than gasoline, and diesel engines produced better power and required less service than gasoline engines. In about 1973, a few companies added pusher chassis, placing the engine in the rear rather than the front of their coaches. One of the primary sources of these first RV diesel engines was the Cummins engine company of Columbus, Indiana. Diesel engines were an established source of power for heavy construction equipment and highway trucks, so their application in the larger motor homes seemed natural. Cummins had proved the ability for its engines to maintain rapid speeds by participating in

the Indianapolis 500 auto race for many years. A Cummins diesel car had won the coveted pole position in 1952, and later, a Cummins Special driven by noted race driver Al Unser won the race in 1987. These applications of diesel power helped greatly to make diesel engines and their different, foul-smelling fuel more acceptable to many consumers. As larger coaches became more and more poplar through the 1980s and '90s, Cummins diesel engines became the power plant of choice for many RV manufacturers building on both the rear engine pusher and what has become known as FRED (front engine diesel) chassis.

In 1974, Postle Aluminum Company was created in Elkhart to provide a variety of aluminum products and services to the RV industry, including extrusions, anodizing and painting of aluminum. Postle Aluminum has grown to five plants throughout the Greater South Bend–Elkhart area and in 2015 was acquired by Thor Industries.

In 1956, Larry Lippert started Lippert Components in central Michigan as a supplier of metal roofing materials for the RV and mobile home industry. In 1987, Lippert acquired its major competitor, Riblet Industries of Elkhart, a provider of frames and chassis to the industry, nearly doubling its sales volume. At this point, the company relocated its headquarters to Elkhart, where a large percentage of its customers were based. In 1992, Lippert was a major supplier of frames for the FEMA trailers built for the relief of Hurricane Andrew. Through the years, with the acquisition of many smaller frame and other product manufacturers, Lippert has become one of the largest component suppliers to the RV industry. In 2003, Jason Lippert, grandson of the founder, became CEO, and he has continued to grow the company through acquisition of a wide variety of trailer components. Today, in addition to frames, Lippert supplies exterior doors, slide-out mechanisms, leveling systems, seating fixtures, window glass and electronics and has become one of the largest providers of parts to the RV industry. Lippert Components is now a subsidiary of Drew Industries.

In 1982, Hal Fowler, an RV salesman, created DTI as a warehouse distribution center for RV parts and accessories in Bristol. After working in RV sales and for other parts distributors around the country, he recognized a need for quick, responsive delivery of needed parts to RV dealers and service centers. Needing a name for his new venture, he resurrected a name that he and his wife, Sue, had used with a boat top sales operation he had run in the 1960s, Dutchess Tops Incorporated. Tops not being a part of his new business, he simply shortened it to the three initials. Working with the philosophy of immediate shipment of parts for every item he represented,

he established a system in which parts were pulled from his warehouse as soon as the order was taken and shipped within twenty-four hours. His system became so successful that DTI became the largest aftermarket parts distributor in the country, and Hal Fowler was recognized in 1996 as the RV Executive of the Year.

In 1986, Duncan RV Repair was formed in Elkhart to provide RV repair service to all brands of recreational vehicles. In 1989, it added RV glass service and, as Duncan Systems, grew into the largest RV glass replacement service company in the nation. In the 1990s, it reestablished its emphasis on full-service RV repair and in 2004 built a forty-thousand-square-foot repair facility that would enable it to handle any kind of RV repair needed. It then added a modern down-draft paint booth large enough to provide full paint services on any size RVs. Duncan RV Repair is one of the largest and best-known independent repair facilities in the United States. In 2014, Duncan Systems was acquired by Lippert Components.

In 2000, the Chevrolet division of General Motors Corporation determined that it would discontinue providing the bare rail P chassis, class-A motor home bases that it had built for over thirty years. This caused a near panic in the RV motor home world, as the Chevy chassis was one of the most popular bases for gasoline-powered motor homes. The Workhorse Company of Union City, Indiana, came to the rescue and contracted to obtain the large Chevrolet RV engines and designed the W series RV chassis using Chevrolet engines to meet the needs of the RV manufacturers.

CHAPTER 7
The Retailers

In addition to the hundreds of manufacturers and parts suppliers that have made Indiana their home through the past century or so, several RV dealers from Indiana have played a major role in the growth of the popularity of the RV lifestyle. The public's access to RVs and the camping and RV travel lifestyle is most commonly through retail dealers and service providers, not directly through the manufacturers themselves. Some RV dealers are franchised to represent one brand or one manufacturer alone, but many carry a wider selection of styles and brands.

In 1935, Pete Callender, who operated a gasoline service station on the south side of South Bend, recognized a need and created fifteen trailer parking sites with water and electric hook-ups in the large lot behind his station. Desiring to do things correctly, he applied to the State of Indiana for a license for his "trailer park." When he learned that Indiana provided no standards or licensing for trailer parks, he applied for and received a license for a tourist cabin operation, with his customers providing their own "cabins." He began what is undoubtedly the first licensed RV park in Indiana. Because he offered water and electric service hook-ups and outhouses, his camp became very popular with the vaudeville, carnival and other show business people who came to perform at South Bend theaters and events. Fred Fontaine—later known as "Crazy Guggenheim" on Jackie Gleason's early TV show *The Honeymooners*—was a regular. Callender's site fee of three dollars per week was affordable in those Depression days. As his trailer business became more and more popular, Pete took on a

Pete Callender. A pioneer trailer dealer, starting in the mid-1930s, Pete sold RVs on the south side of South Bend for over sixty years. *Courtesy of the RV/MH Hall of Fame.*

popular line of trailers for sale. With his park and sales lot growing rapidly, he shortly abandoned the gas station business and concentrated on the trailer business for the next sixty years. As South Bend grew around him and crowded him out, he was forced to relocate his business a few miles south in the small town of Lakeville. When his business moved from the gas station location, Pete left the trailer park–campground business and concentrated his attention on his retail sales. Pete always considered himself a trailer salesman and never decided to favor the RV side or the manufactured housing side as the two industries grew apart. He was known to say that if an auto dealer could sell both cars and trucks in the same store, he could likewise sell campers and mobile homes together. As his business grew, Pete became very well known and respected on both the local and national dealer levels as one of the early multi-line independent dealers. He was very active on state and national association boards, serving two terms as president, in 1954 and 1966, of the Indiana association. He was one of the first presidents of the national Recreational Vehicle Dealers Association (RVDA) and served for twenty years on its board of directors. He was one of the founders of the service technician schools sponsored by the national dealers' association.

In the late 1950s, a young man named Tom Raper, who grew up on a farm south of Richmond, Indiana, was earning his way through the University of Cincinnati by selling encyclopedias door to door. An outstanding sales personality, he became the top encyclopedia salesman in three states while attending college. After college, he worked in sales for International

Harvester but was not satisfied with the job, so in 1964, he started a used car dealership in Richmond with a total investment of about $2,000. A few years later, he added a line of campers to his inventory, and by 1969, he had settled completely into the RV sales business. Tom Raper RV Sales grew rapidly and, in 1977, moved into a large new facility on Williamsburg Pike that, in 1986, grew to include a huge indoor showroom capable of displaying ninety RVs indoors. In 1999, Tom Raper RV Sales was shown to have sold more RVs than any other dealership in the country since 1992 and claimed the title of the "World's Largest RV Dealer." In 2000, following some major health issues, Raper sold his namesake dealership to his general manager and retired. For many years, central Indiana residents heard and read Tom's motto in his advertising on radio, television and billboards: "Save Today the Tom Raper Way." In 2014, the dealership's many contributions to the Richmond community were honored by the city when Williamsburg Pike was renamed Tom Raper Way, recognizing the motto it had used for many years.

Since 1978, Tom Stinnett has been selling RVs to customers from around the country from Clarksville, Indiana, directly across the Ohio River from Louisville, Kentucky. Tom has built his dealership to include a 104,000-square-foot indoor showroom identified as the largest indoor RV showroom in the nation. Stinnett has been active with national dealer and manufacturer associations, was elected chairman of the national RVDA and has served since its founding as the co-chairman of the RVIA-RVDA-sponsored national marketing "Go RVing" campaign promoting the RV lifestyle on television and in print. Under Tom's leadership, Go RVing has been recognized as one of the most successful marketing efforts in any industry. Tom also expanded his involvement in the RV industry with the creation of Equine Motor Homes, a line of very high-luxury combination horse van and living unit coaches for the horse show and horse racing community. Introduced in 2007, Equine Motor Homes were first produced in Europe to take advantage of certain technologies available there, but in 2012, Kibbi LLC of Bristol, Indiana, the builder of Renegade brand super C coaches, contracted to become the manufacturer of Equine Motor Homes.

In 1987, Richard Aker of Elkhart created Hart City RV Center, which grew to become the third-largest RV dealership in the state and the nation's largest dealer of Newmar brand RVs. Aker was very active in RV association work on both the state and national level and became the president of the national RVDA.

Indiana RV dealerships continue to be created. In September 2014, Dzung Nguyn, a Vietnam refugee immigrant and Goshen auto dealer, established the Goshen RV Supercenter as a full-service RV store representing a wide variety of Indiana-based RV companies.

CHAPTER 8

The Bus Converters

From the very first days of motorized RVs, the larger housecars were historically created by reconfiguring used highway buses into comfortable, livable motor coaches. This standard was followed through the 1930s, '40s and '50s, even though some creative individuals did acquire truck chassis and build their travel houses on the trucks from scratch. By the late 1950s and early '60s, hundreds of used highway buses had been converted into recreational vehicles and were traveling to major attractions and events around the country. In the early 1960s, several major bus manufacturers—notably Canada's Prevost Car Company, the Flxible Bus Company of Ohio and Illinois-based Motor Coach Industries (MCI)—began to make their chassis and bare bodies available to professional shops for the purpose of creating high-value luxury motor coaches on brand-new, rather than used, platforms.

In 1965, Phil and Bea Robertson of Angola, after converting a few used buses, began to purchase new empty bus chassis and determined to create the finest, most comfortable traveling coach that they could. For nearly thirty years, Angola Coach Corporation annually produced eight to ten of the most luxurious buses on our roads. Angola Coach's customers included corporate executives and celebrities such as NASCAR driver Tony Stewart. The Robertsons continued with their very limited production schedule until 1994, when they ceased production and closed the business, which was then sold to new owners. The new owners attempted to dramatically increase production levels to twenty-five to

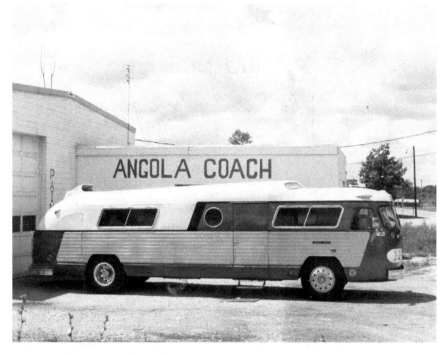

An early Angola Coach bus conversion. This is one of the used late 1930s highway buses converted by the Robertsons at the beginning of Angola Coach. *Courtesy of the RV/MH Hall of Fame.*

thirty coaches and sold off some related properties to reduce costs but closed their efforts in 2001.

In 1977, George and Mary Comish of Elkhart formed the Royal Motor Coach Company to convert Prevost bus chassis into very large, highly luxurious coaches that equaled the finest traveling coaches made anywhere. The coaches were completely made to order, and some were so extremely specialized as to include such features as a complete operating room in the rear for a traveling surgeon. Royal Motor Coach's production was so meticulous that it produced only fifteen coaches per year. In 1989, West Coast builder Monaco Coach, along with some investor partners, purchased Royal Motor Coach and raised the production level to twenty-four coaches per year. Monaco added an "e" to the company name and, as Royale Coach, produced luxury coaches priced well into the $1 million range. Royale Coaches were known for their exceptional cabinetry and woodwork, and each coach could take up to seven thousand man hours of labor to complete. Royale Coaches were custom made for their clients and were also stocked by

Knoxville, Tennessee's Buddy Gregg Motorhomes as an exclusive national dealer where finished coaches could be purchased off a sales lot. Royale Coach by Monaco vehicles continued to be built in Elkhart until December 2005, when production ceased.

In 2006, Royale Coach personnel Dan Jourdan and Glenn Berden established the Royal Phoenix RV Company to build much smaller type-B and C motor homes of high quality and also to provide service and repairs to Royale Coach owners. As a related service, they provide experienced and qualified drivers to pick up customers' RVs from anywhere in the United States or Canada and bring them to the Elkhart location for service. Royal Phoenix has also converted a few Prevost bus chassis for customers, including the owner of another Elkhart-based RV company.

In 2000, Kerm Troyer, who had built large live-in-style horse trailers in his shop in Middlebury, created ShowHauler Motorhome Conversions to stretch and convert full-sized highway semi-truck tractors into very powerful, totally custom-made, luxury motor coaches. Originally designed as luxurious, on-the-road housing for his horse show clientele, ShowHauler's customer body has grown to have received, as of 2015, over 1,500 custom motor homes for a wide range of customers. By using the largest highway semi tractors as the basis for its motor coaches, Showhauler is able to provide towing capacity for any trailer its customers may need to tow.

EPILOGUE
The Future?

Two major events that took place in June 2016 in Elkhart County will affect the future of the RV industry both locally and nationally for many years to come. The financial crisis that generated the sudden and unexpected closing of Evergreen and its luxury fifth-wheel division, Lifestyle RV, along with an auction sale of all of its assets except real estate, eliminated the fastest-growing eco-friendly, green-rated company in the industry. Having received many national and international recognitions for its innovative designs and advances in green technology, the sudden closing of all Evergreen operations sent a shock through the RV world. Following the previous failures of Pilgrim and Earthbound as eco-friendly RV manufacturers, the loss of Evergreen may make innovative investors hesitate to continue to develop green RVs.

On June 30, 2016, Thor Industries, one of the two largest companies in the RV industry, purchased 100 percent of Jayco, the third-largest manufacturer. This combine created a single monster company that holds nearly a 50 percent market share in the RV world. The fact that Thor routinely allows the existing management team to continue to operate the companies that it acquires may tend to alleviate concerns of one giant firm monopolizing the RV industry, but it is sure that the fear may arise. The press notices regarding the merger assure that the Bontrager family that founded and built Jayco and has been in control since 1968 will continue to run the division under the Thor umbrella.

That being said, the future looks continuously bright for Indiana's RV industry. While the RV companies and their support structure will

always be at the mercy of major economic events, there is no sign that the American people do not want to continue in their love of travel and outdoor recreation. Modern RV travel gives families the opportunity to take their luxury hotel suite with them and comfortably see the country inch by inch up close and personal instead of flying five miles high from hotel to hotel. Starting with the effects of the Great Depression and through World War II, the gas crises of the 1970s and the early 1990s and lately the 2008–09 downturn, each and every time the industry has been drastically affected, but the companies that have survived have returned with greater strength than before. With by far the two largest corporations in the RV world centered in Elkhart—along with twenty-five or more other companies of various sizes and another major concentration of motor home builders south of Fort Wayne with American Coach and the other old Fleetwood Enterprises brands, as well as the Monaco models and their relatives of Safari, National and Holiday Rambler—the whole northern Indiana region is birthplace to a huge majority of the world's RVs. The remarkable development of Thor Industries, now centered in Elkhart, and Forest River, which was born and raised in Elkhart, has quite dramatically altered the recreational vehicle landscape in the past couple of decades. These two giant companies, with Thor now having a legitimate claim on being the largest RV builder, now jointly hold about an 80 percent market share in RV sales. Both have grown primarily by acquisition of smaller competitors, but both have also introduced new brands. Each has allowed its acquisitions to continue to operate as separate entities in "friendly" competition with each other.

On October 3, 2016, it was announced that Grand Design had been acquired by industry giant Winnebago Industries, thus becoming the second Indiana company to join with Winnebago. It was announced that the Grand Design lineup would continue to be built in Middlebury and that the leadership team that had so successfully grown the company in its three short years of existence would continue in charge. This event gives another iconic RV manufacturer a firm footing in northern Indiana, with Winnebago Industries, based in Iowa since the 1950s, now having both Sunnybrook and Grand Design as parts of its operation.

Through the more than one hundred years of RV industry history, many different companies have, for a period, held the position of largest manufacturer, but never has market share been as concentrated as it is today. That concentration is based firmly in northern Indiana. It remains to be seen what effect this status will have on the opportunity

106

for innovative entrepreneurs to bring new ideas and products into the market.

As the RV industry reorganizes itself and gets used to its new landscape, new features are sure to be added to make RV travel more luxurious and comfortable in larger, more spacious mobile mansions. Larger fifth-wheel trailers and motor coaches add full-length slide-outs that nearly double their available space and grow to include everything from interior stairways to fully equipped rooftop lounges. Smaller trailers and micro-sized motor homes will use the latest technology to become lighter and have increased comfort and livability. Tiny teardrop-style trailers that were originally little more than a bed in a box continue to add hot and cold running water, heat and air conditioning and refrigeration to replace camp coolers, becoming nearly as well furnished as larger-sized RVs.

We may see a return to amphibious RVs, as were first seen in small trailers in the 1950s and 1960s and in a few motor coaches in the early twenty-first century. We may see flying RVs, as were first seen in the 1970s. There is talk of driverless cars, and we may see the day when we can program a digital chauffeur to take us and our party to our chosen destination in luxury comparable to any fine hotel or office suite.

Alternative fuels and power supplies are already known in electric autos and propane- or hydrogen-powered cars and buses, so it is probably only a matter of time before "clean fuel" RVs become available.

Creative RV engineers like those in other industries continue to prove that with the level of technology available today, "if you can dream it, you can build it."

Some of the RV Brands Made in the Greater South Bend-Elkhart Area Throughout the Years

Acclaim	Avalanche	Bivoac
Admiral	Avalon	Blackhawk
Adrenaline	Avenger	Blazer
Aerolite	Avion	Blazon
Alante	Axxess	Blue Ridge
Aljo	Ayr Way	Bobby
Alumascape	B&G	Bobcat
Ambition	Banner	BonAire
Ameri-Camp	Barth	Bonanza
American Coach	Bay Hill	Breckenridge
American Star	Beach-craft	Brookstone
Apache	Bearcat	B-T Cruiser
Apex	Beechwood	Buccaneer
Aquarius	Bee Line	Bullet
Aristocrat	Bentley	Cabana
Arro	Berkshire	Cadet
Arrow	Big Country	Cameo
Ascend	Bighorn	Camp-a-While
Aspen Trail	Bilanco	Camp Craft
Astoria	Bison	Campfire

Camp 4	Danny Boy	Fleetwing
Camplite	Daybreak	Forest River
Camp Master	DeCamp	Forke
Campsation	Del Rey	Four Seasons
Canyon Star	Delta	Four Winds
Canyon Trail	Denali	Franklin
Caravans International	Designer	Freedom Express
Cardinal	DeVille	Freelander
Carriage	Doubletree	Friendship
Carri-lite	Drexler	Frolic
Casual	DRV	Fun Finder
Cedar Creek	Durango	Fuzion
Challenger	Dutchman	Galleria
Chaparral	Dutch Star	Garway
Charlette	Dynamax	Garwood
Chateau	DynaQuest	Georgetown
Cherokee	Eagle	Georgie Boy
Cikira	Earthbound	Ghost
Clipper	Easy Traveler	Globestar
Coachmen	Elcar	Gold
Cobra	Element	Grand Design
Columbus	Elevation	Gran Dee
Comanche	Elite Suites	Greyhawk
Compass	Elkhart Traveler	Gulf Breeze
Concord	Elk Ridge	Gulfstream
Conquest	Embark	Harris Caravan
Continental	Endeaver	Haulmark
Cougar	Endura	Heartland
Covered Wagon	Entegra Coach	Heckaman
Cozy Traveler	Envoy	Heritage
Cree	Equine Motor Coach	High Country
Crescendo	Essex	Highland Ridge
CrossRoads	Estate	Holiday Rambler
Crossroads Traveler	Eterniti	Holiday Traveler
Cruise Aire	Evergreen	Holiday Vacationer
Cruise Master	Express	Home Comfort
Cruiser	FAN	Honey
Cyclone	Fifth Season	Hop-Cap
Damon	Flagstaff	Hornet

Hummingbird
Hurricane
Ideal
I-Go
Imagine
Impala
Imperial
Independence
Indy
Infinity
Innsbruck
Instinct
Intrepid
Intruder
Isata
Jayco
Jay Feather
Jay Flight
Jeep
Joey
Juno
Keystone
King Aire
Kodiak
Kom-Pak
Kon Tiki
Kountry Aire
Kountry Star
Kropf
K-Z
Lacrosse
Lakeview
Landau
Landmark
Laredo
LaSalle
Layton
Ledgerwood
Leer

Leisure-Craft
Leisure Time
Leprechaun
Lexington
Liberty
Lifestyle
Lil' Hobo
Lil' Sport Coach
Little Guy
Livin' Lite
London Aire
Luxe
Lynn
Magic Car Pet
Majestic
Malibu
Mandalay
Maple Leaf
Marathon
Mark Twain Traveler
Marque
Maverick
Mayfair
Melbourne
Merow
Mirada
Mirage
Mobile Suites
Momentum
Monaco
Monarch
Monitor
Montana
Montecito
Motor Homes
 Unlimited
Mountain Climber
Mountaineer
MPG

Murray
Mustang
MXT
Navigator
Neptune
Newaire
Newcomer
Newmar
Next Level
Nexus
Nomad
Northern Lite
North Point
Oakmont
Octane
Open Range
Outback
Overland
Pacemaker
Palomino
Pathfinder
Penguin
Phantom
Phoenix
Phoenix Cruiser
Pilgrim
Pinnacle
Platt
Polaris
Ponderosa
Prairie Schooner
Precept
Premier
Presidential
Prime Time
Prism
Prowler
Puma
Pursuit

Quicksilver
Radiance
Rampage
Razorback
Rebco
Reco
Recreation by Design
Redhawk
Redwood
Reflection
Renegade
Resort
Richardson
River Canyon
Road King
Road Rover
Road Warrior
Rockwood
Royal Coach
Royals International
Royal Wilhelm
R-Pod
Rubicon
Rushmore
Sabre
Salem
Sandpiper
S&S
Sandstorm
Savoy
Scorpion
Sedona
Seismic Wave
Select
Sells
Seneca
Shadow Cruiser
Shasta
Ship-n-Shore

Shockwave
Showhauler
Sierra
Skamper
Skylark
Skyline
Smoker
Sol Aire
Solitude
Solstice
Space Age
Sport Craft
Sportscoach
Sportsman
Spree
Springdale
Sprinter
Sprite
Spyder
Stage Coach
Stampede
Starcraft
Starflite
Startracks
Stealth
Steury
Stewart
Stutz Bearcat
Summit
Summit Ridge
Sunnybrook
Sunrader
Sunseeker
Sunset Trail
Sun Valley
Sunway
Superior
Surveyor
Swinger

Swiss Colony
Sycamore
T@B
Tel-Star
Thunderbird
Time Out
Torque
Tourmaster
Towmaster
Tradition
Trail-a-Home
Trailmaster
Trail Star
Transit
Trans-Por-Ter
Travelcraft
Travel Equipment
Travel Line
Travelmaster
Travel Supreme
Travel Units
Trek
Trilogy
Tri State Traveler
Trophy
Turtle Top
Twilight Camper
Unique
Utopia
Vacation Homes
Van American
Vega
Vengeance
Venom
Ventana
Venture
Victor
Victour
Viking

Vintage Cruiser
Viper
Vision
Vista Cruiser
Voltage
Walco
Weekender
Wheel Camper
White Hawk
Whiteman
Wildcat
Wildwood
Windjammer
Windsport
Winnebago
Winnie Drop
Wolf Pup
Work and Play
Wrangler
XLR
Xplorer
Yellowbird
Yellowstone
Yukon Delta
Zinger

Indiana RV Leaders Recognized with Induction into the National RV/MH Hall of Fame and Their Companies

Able, Paul—Franklin Coach
Bassett, Ray—Honey RV
Beck, Ermon—Beck Industries
Beck, Roy—Beck Industries
Bock, August—Bock Frames
Bontrager, Lloyd—Jayco
Bontrager, Wilbur—Jayco
Brown, Glenn—Bristol Trailer Plumbing
Callender, Pete—South Side Trailer Sales
Corson, Tom—Coachmen
Decio, Arthur—Skyline
Deitch, Bill—LaSalle Bristol
Ellis, Joe—LaSalle Bristol
Fisher, Mike—Fisher Travel Trailers
Fowler, Hal—DTI
Gardner, Stewart—Stewart Coach
Gerring, Hal—Ger/Win, Amerigo
Hussey, Ed—Liberty Homes
Klingler, Richard—Holiday Rambler
Kropf, Bob—Kropf Industries
Liegl, Pete—Forest River

Lippert, Larry—Lippert Components
Lux, Phillip—Coachmen
Miller, Charles—Reese Hitch
Miller, Mahlon—Holiday Rambler, Newmar
Miller, Milo—Sportsman, Elcar, National
Miller, Virgil—Newmar
Morgan, Ralph—Morgan Drive Away
Newcomer, Franklin—Franklin Coach, FAN, Monitor
Orthwein, Peter—Thor Industries
Overhulser, Bill—Del Rey
Pickrell, Jerry—LaSalle Bristol
Platt, Harold—Platt Trailers
Pletcher, Don—Mallard, Damon
Raker, Gene—Peerless Trailers
Reese, Terrell—Reese Industries
Reeves, Herb, Jr.—Florence Stoves, Covered Wagon, Arrowhead Park
Rose, Kelly—Starcraft, Evergreen
Sailor, Vern—Sailor Door
Schult, Wilbur—Schult Homes
Searer, Darryl—Ultra Fab Products
Shahnasarian, Leon—Instamatic Corp. Dometic
Shea, Jim, Jr.—Gulfstream
Shea, Jim, Sr.—Gulfstream
Stinnett, Tom—Tom Stinnett Sales
Stout, Gene—Coachmen
Thompson, B.J.—B.J. Thompson and Associates
Thompson, Wade—Thor Industries
Yoder, Al, Jr.—Jayco
Yoder, C.T.—Carriage
Yoder, Perry—Maple Leaf, Carriage

Bibliography

Atlas Mobile Home Museum. www.allmanufacturedhomes.com.

Edwards, Carl. *Homes for Travel and Living*. East Lansing: Michigan State University, 1972.

Hesselbart, Al. *The Dumb Things Sold...Just Like That!* N.p.: RV History Programs, 2007.

Jacques, Jean. "The Elkhart Story." *Trail-R-News* magazine, 1949.

Silvey, Joel. "Pop-up Camper History." 2009. www.popupcamperhistory.com.

Trailer Life. "Trailer News." www.trailerlife.com/camper-trailer-news.

Wasson, Mark, vice-president, BlueLinx Corporation. Correspondence with author, personal thoughts on Georgia Pacific.

Westward Coach Manufacturing Company v. Ford Motor Company. 388 F. 2d 627, January 1968.

Index

About the Author

Al Hesselbart has lived
a multi-featured life.
As an active Boy Scout
growing up, he earned
his Eagle Scout badge
and was awarded the
Vigil Honor in the scouts'
honorary Order of the
Arrow and a Scouter's
Key as an adult leader.
After graduating from
Owosso High School
in Owosso, Michigan,
where he earned athletic
letters in wrestling and

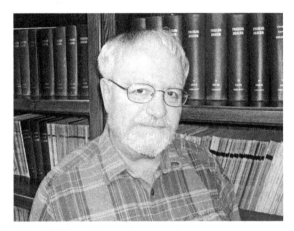

Courtesy of Tom McNulty.

tennis and wrote for the student newspaper, he attended Albion College for
a couple of years before moving to Michigan State University, where he
played goalie on a Canadian-led intramural hockey team and graduated
with a business degree, majoring in personnel administration. Having had
student employment with the University Department of Public Safety, upon
graduation he joined the department as a law enforcement officer, serving
during the second half of the 1960s. He became a faculty member of the
Mid Michigan Police Academy, training officer recruits from over twenty

A 1962 Yellowbird pop-up tent trailer by Heckaman. This is one of the very basic, no tip-out campers of the early '60s and was the author's very first RV. *Courtesy of Al Hesselbart.*

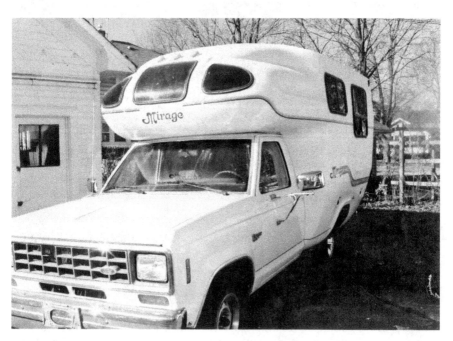

A 1984 Mirage RV. This is one of the very small micro-minnie motor homes made in the early 1980s. *Courtesy of Al Hesselbart.*

departments in firearms and marksmanship as a nationally certified police firearms instructor.

In mid-1969, he left law enforcement and, having been recruited because of the reputation he earned during summer employment leading Boy Scout summer camps throughout the Midwest, joined the field staff of the Boy Scouts of America, where he served scout councils in Flint, Michigan; Wheaton, Illinois; and South Bend, Indiana, as a unit organizer, volunteer trainer, coordinator and summer camp director and served as a faculty member of the Boy Scouts' National Camp Schools, training and certifying camp administrators and leaders from around the country. The economic downturn of 1980 caught Al, and he was downsized out of his youth service career.

Needing a job when there were none to be had during the recession, in order to support his three children, he became a full-commission new car salesman, getting paid only when he sold a car. He became fairly successful as a retail salesman of several brands of imported autos and was recognized as his employer's top new auto salesman four years in a row. His auto sales career ended shortly after his marriage ended, and he became the custodial parent of three elementary school–aged children, making six-days-a-week retail hours, including several evenings, impossible to manage. During his time with the Boy Scouts, he had related to the man who had become the president of the RV/MH Heritage Foundation, and he invited him to become the vice-president and manager of the national RV and mobile home museum. His duties evolved into recognition as one of the nation's leading authorities on RV history. He has appeared at over one hundred shows and rallies, including twice speaking at RV events in China, and has appeared in numerous television documentaries both domestically and abroad on the history of RVs. Having retired from his position with the RV/MH Hall of Fame Museum, he now writes a few articles and appears at a few RV shows and rallies. Al has entered a new phase of his life, performing as a recitation song artist in country music jam sessions throughout central Florida. He now lives full time in his vintage Newell motor home based in Florida.